Pompano Beach

The landmark Hillsboro Lighthouse dominates Hillsboro Inlet at the northern border of Pompano Beach. The lighthouse has operated for more than one hundred years. *Author Collection.*

Pompano Beach
a history

Frank J. Cavaioli

Charleston · London
History PRESS

Published by The History Press
Charleston, SC 29403
www.historypress.net

Copyright © 2007 by Frank J. Cavaioli
All rights reserved

Cover design by Marshall Hudson.

First published 2007

Manufactured in the United Kingdom

ISBN 978.1.59629.280.2

Library of Congress Cataloging-in-Publication Data

Cavaioli, Frank J.
Pompano Beach : a history / Frank J. Cavaioli.
p. cm.
Includes bibliographical references and index.
ISBN 978-1-59629-280-2 (alk. paper)
1. Pompano Beach (Fla.)--History. 2. Pompano Beach (Fla.)--Social
conditions. 3. Pompano Beach (Fla.)--Social life and customs. 4. Seaside
resorts--Florida--Pompano Beach--History. I. Title.
F319.P664C385 2007
975.9'35--dc22
 2007035342

Notice: The information in this book is true and complete to the best of our knowledge. It is offered without guarantee on the part of the author or The History Press. The author and The History Press disclaim all liability in connection with the use of this book.

All rights reserved. No part of this book may be reproduced or transmitted in any form whatsoever without prior written permission from the publisher except in the case of brief quotations embodied in critical articles and reviews.

I dedicate this book to Lorraine whose love, understanding and patience have made it possible.

Contents

Acknowledgements 9

Introduction 11

1. The Foundation Years 15
2. The Early Settlers 25
3. Boom and Bust 41
4. The Kester Era 59
5. The World War II Era 71
6. The Modern Era 89
7. The Condominium Era 107
8. Toward the Millennium 125
9. Contemporary Pompano Beach 135

Bibliography 153

Index 157

About the Author 159

Acknowledgements

I would like to acknowledge those individuals who assisted me in one way or another in the production of this book: Mario Battaile, Reverend Anthony Burrell, Mary Chambers, Eunice Cason Harvey, Rosemarie DiGiorgio, Reverend Thomas Foudy, Andrew Gerlach, Daryl Hinkle, Betty Johnson, Betty and Dennis McNab, Kay McGinn, Rosemary Monard, Janice Rolle, Jesse Rosenblum, Larry Shuster and Reverend Buddy Spear.

Introduction

The centennial of Pompano Beach is a grand occasion for celebration. It is an opportunity for individuals and organizations to participate outwardly in various ceremonies through the display and appreciation of their hometown. The city celebrated its fiftieth anniversary in 1958 and its seventy-fifth anniversary in 1983. By doing so, a sense of pride was expressed for such a relatively young community. It is a challenging concept to think of Pompano Beach originating as a frontier community; it was more than one hundred years ago when settlers moved in. On the other hand, a contemporary examination reveals a modern, urbanized, postindustrialized society bordering on the Atlantic Ocean. When the original town was incorporated in 1908 during Theodore Roosevelt's presidency, the population count registered fewer than 250. In contrast, the population counts for 2006 show 101,103 people residing in the city. From a tiny community centered around the Florida East Coast Railroad at Flagler Avenue and nearby Lake Santa Barbara, Old Pompano through the years extended its geographical boundaries in all directions—eastward beyond the Intracoastal Waterway to the Atlantic Ocean, westward past the CSX Railroad to the Florida Turnpike, southward to McNab Road and northward to Sample Road. Today the total geographical area of the city consists of 25.08 square miles.

The most permanent result of the earlier two celebrations can be seen in a written record. *The Historical Souvenir Program 1908–1958* was published in 1958. It listed program events for the week of April 18–19, and identified the city as "The Gem of the Gold Coast," announcing the Golden Jubilee for Greater Pompano Beach. The other celebration was recorded in the publication *Pompano Beach Diamond Commemorative Book Celebrating 75 Years, 1908–1983*; a limited edition was issued June 15, 1983. The official birth of a new Pompano Beach occurred on July 3, 1945, when the beach area inhabitants formed a new government. For two years the two towns coexisted. The movement to merge the separate municipalities of Pompano and Pompano Beach into one political entity resulted in the creation of the new city of Pompano Beach on June 16, 1947, and this arrangement has remained up to the present.

Despite contemporary national and international events dominating current events, considerable interest has arisen in recent years among lay people and professional historians to research and record the historical roots of community life and local

Introduction

The Lake Santa Barbara area is where the original settlers made their homes. Also called Hardy's Lake and Lettuce Lake, the body of water flows into the Intracoastal Waterway. *Author Collection.*

institutions. Raw data and primary sources are being collected and studied. Increased attention has led to more publications detailing the lives and events at the grass roots level. Narratives are now plentiful, though often lacking comprehensive analytic treatment. The interrelationships of historical forces are also missing. Nevertheless, it is important to note the increasing number of museums being created to preserve the physical memory of the past. The relationship between the past and the present has never been more evident. Local history directly touches people's lives.

The rise of the New Social History in the recent twentieth century has generated interest in the story of the inarticulate masses of society. Often referred to as "history from the bottom up"—in contrast to chronicling the accomplishments of the elite—now the role of the "voiceless" masses can be studied and analyzed. The ethnic American, along with workers, children, families, women, immigrants and other neglected persons, is now given more attention in attempting to achieve an accurate understanding of the past. Advances in technology allow the historian/social scientist to gather extensive economic, political and social data to analyze and reach objective conclusions. For example, official census records play a crucial role in this methodology. Genealogy has also played an important role.

Introduction

Herein lies a direct relation to the history of the origins and growth of Pompano Beach. No standard, definitive history of Pompano Beach exists. This study attempts to fill that void by demonstrating how this community has developed. It focuses on the lives of individuals and the evolving institutions that shaped them. Contributions of such early settlers as Frank Sheene, Isaac Hardy, James E. Hamilton, William Blount, Jonathon Rolle, William L. Kester, James Emmanuel Coleman, Albert Neal Sample, Blanche Ely, Harry McNab and Robert McNab, among many others, are examined. The completion of the Pompano Canal in 1890, the Flagler East Coast Railway in 1896 and the Intracoastal Waterway all helped to influence Pompano. The impact of hurricanes, the real estate boom of the 1920s, the Great Depression, World War II, the decline of an agricultural economy and the beginning of tourism, the rise of condominium and suburban lifestyles, the construction of shopping malls, sporting events, political changes and organizational life are some of the major topics that are studied. Changing life patterns will be considered within the context of county and state backgrounds.

Writing a comprehensive history of Pompano Beach has been a challenging intellectual endeavor. Nevertheless, it has been a satisfying experience for this author. It is my hope that you will enjoy reading it as much as I enjoyed writing it.

1.

The Foundation Years

The primitive settlement of Lake Santa Barbara in the late nineteenth century, an area which emerged as an evolving prosperous Pompano Beach community, represents the triumph of a small group of settlers who overcame natural environmental obstacles. These pioneers laid the foundation for a modern city of more than 101,000 people to celebrate its centennial—a rare event in the local history of modern Florida.

The historical origins of Pompano Beach as part of Broward County date back to the earliest development of Florida thousands of years ago. The first settlers were Tequesta American Indians who lived in the region from Cape Sable to contemporary Pompano Beach. The Tequesta left no written records, although a 1938 excavation of the Indian Mound at Southeast Thirteenth Street and Hibiscus Avenue on the east side of Lake Santa Barbara near State Road A1A, revealed a wooden artifact believed to be pre-Columbian, about 1,300 years old. Lake Santa Barbara was also known as Lettuce Lake because of the vegetation that grew there, as well as Hardy's Lake, named for one of the earliest settlers who lived there. Archeologists have identified the wooden figure as "Keeper of the Mound." One of the first archeological digs took place in 1938, led by Professor John N. Goggin, an anthropologist from the University of Florida who excavated the mound and discovered the wooden figure.

The mound contains Native American dead. The Tequesta raised the mound by hand labor, carrying baskets of sand and creating monuments containing the bones of friends, family and community leaders. When Tequesta died their bones were taken to a special place to decompose. The bones were cleaned, bundled and saved to be buried in the mounds. The Tequesta valued the dead. Thus, more than 1,300 years ago, anthropologists have concluded, there was a village in the Pompano area where Native Americans worked, raised families and participated in joyous festivals, solemn rituals and other colorful ceremonies. It was a place where food and fish were abundant, potters created vessels, canoes were constructed, nets woven and medicines were prepared. The activities of Florida Indians were similar to other American Indians. Recognizing its historical significance, the City of Pompano Beach has maintained the Indian Mound Park as a passive park and placed a relevant historical marker at the site stating, "Pompano Beach has designated Indian Mound Park as a Memorial Landscape where living trees preserve the memory of those we love."

Indian Mound Park is where pre-Columbian Tequesta American Indians buried their dead in elaborate ceremonies. It lies east of Lake Santa Barbara at Southeast Thirteenth Street. The city maintains the park for its historical importance. *Author Collection.*

Writing a history of Broward County for a WPA Federal Writers Project in 1936, author Frances H. Miner described Broward "in embryo" as follows:

> *The Everglades, stretching inland from the sea; vast, mysterious, impenetrable, hammock and glade matted with tough trailing vines and tropical undergrowth; swamp and forest; mangroves on their slow, implacable march to the ocean; the home of wild turkey, of families of chattering parakeets; panther, bear, the predatory wolf; the Indian. This was Broward County in embryo. It was a country that long blocked the efforts of exploration; the coming of the white was delayed.*

The Spanish explorer Juan Ponce de León arrived in 1513 in the St. Augustine area. It is believed that other European explorers followed, although no permanent settlement was established at this time. Ponce de León named the area "Florida," which later became the State of Florida. It had rich natural vegetation and the discovery occurred at the time of the Spanish Feast of the Flowers. In 1521 Juan Ponce de León made a second landing to establish a plantation community—the first real attempt at settlement in Florida. The plantation settlement failed soon after. Other explorers and adventurers made landfall, but they did not find the gold and glory they were seeking. Finally in 1565 at St. Augustine, the Spanish, under Pedro Menéndez de Aviles, established the first permanent settlement in Florida and in what would become the United States of America.

The Foundation Years

The Spanish continued to control and settle Florida during the seventeenth century. In the eighteenth century Great Britain contended for control with Spain as each country's fortunes shifted with time. Border disputes continued. Spain ceded Louisiana to France in 1800, and three years later President Thomas Jefferson executed the Louisiana Purchase and claimed West Florida. By 1819, General Andrew Jackson successfully secured the area for the United States. Finally, in 1821, the United States gained possession of Florida from Spain. Andrew Jackson of Tennessee became the first territorial governor. By 1830 the population of Florida was recorded at 34,730; ten years later it increased to 54,477.

The early development of Florida witnessed conflict with the American Indians as more white settlers moved into the area. Governor Andrew Jackson set out to remove the Native Americans. Casualties mounted on both sides, especially during the Seminole Wars of the 1830s and 1840s. The great American Indian leader Osceola was captured in 1837 and died later at Fort Moultrie, South Carolina. In 1842 the United States declared the Second Seminole War ended.

With the region now stabilized, the inhabitants could concentrate on moving to statehood. Florida entered the United States as a state in 1845. William D. Moseley served as the first governor; David Yulee became the first congressional representative. The population reached 66,500. During the Civil War, Florida sided with the South, seceded from the Union (January 1861), joined the Southern Confederacy, lost the war and endured the Reconstruction Period (1865–1877). Upon returning to the Union, Florida reverted to many of its former antebellum institutions. Although slavery was abolished, new systems were put in place to maintain white supremacy. The poll tax, white primary and segregation in public facilities prevailed. Five flags have flown over Florida from Spain, France, Great Britain, the United States and the Confederate States of America.

Throughout American history the federal and state governments have played an important role in developing the internal improvements of the nation. What the private sector was unable or unwilling to accomplish, government would provide. Such was the case with the government's involvement in the advancement of the internal improvements of Florida, whose vast natural resources needed to attract people and capital. The newly formed state created the Internal Improvement Fund to control the rights and title of submerged land. By law, the fund was controlled by the governor and his cabinet members who served as trustees of the fund and managed the distribution of swamplands.

In 1850 the United States government, under the Swamp Lands Act, gave all public lands it owned to the State of Florida. The purpose was to have the state develop internal improvements for its advancement. The Florida Coast Line Canal and Transportation Company, formed in 1881, received thousands of acres of swampland with the understanding that it would build a canal along the east coast. Work began in 1883. The concept of the Intracoastal Waterway arose out of the desire to connect the chain of rivers, lakes and lagoons along Florida's east coast. The canal's dimensions were to be fifty feet wide and five feet deep. The Canal and Transportation Company

received 3,840 acres of land in the proximity of the canal for each mile completed at the waterway. This new transportation system would connect Jacksonville in the north to Biscayne Bay in the south. Along its way, new communities would emerge, attracting people and investments. The area around what would become Pompano Beach benefited from such a farsighted plan. The original east coast canal, or waterway, is today a part of the Atlantic Intracoastal Waterway, which is a continuous system of sheltered inland channels for commercial barges and pleasure boats that extends from Key West northward to Maine. Observers have referred to it as "the equivalent of U.S. Highway 1."

Florida's population rose from 140,000 in 1860 to 530,000 forty years later. Its warm climate and natural resources attracted a growing number of tourists, sportsmen and investors. With the building of the Intracoastal Waterway, the other component needed for growth was an intrastate railroad system. Henry Bradley Plant met the challenge after the Civil War by successfully constructing and consolidating over six hundred miles of railroad track in the western region of the Florida peninsula. Plant took advantage of the land bonuses that the state gave for each mile of railroad that was built. He based his company in Tampa and expanded into the hotel and steamship businesses.

The other enterpriser who realized the growth potential and benefits of a railroad system was Henry Morison Flagler (1830–1913), who earlier in his career made his fortune with John D. Rockefeller in the success of the Standard Oil Company. He was not content to settle into quiet retirement in Florida. Flagler turned to the eastern part of the state. In 1886 he organized the Florida East Coast Railroad and built a railroad system that extended the length of Florida's east coast to the Keys. As an inducement, Plant and Flagler received thousands of acres of land to build their railroads. The original ten acres of land that constituted the Pompano Cemetery was donated by the Model Land Company, which was the land development agency of the Flagler's East Coast Railway. These men built luxury hotels to accommodate tourists who would be carried by their railroads and would stay at the lavish hotels they built. They established the foundation for a flourishing tourism industry that continues to this day.

One of the most unusual events that characterized the early primitive history of Pompano was the experience of the legendary Barefoot Mailman. In the period covering the years from 1885 to 1892 barefoot mailmen delivered U.S. mail by foot, carrying mail in a pouch along the seacoast between Jupiter and Miami. This system was necessary because mail from Miami was placed on a boat, sent to Key West, to Cuba, then by steamer to New York and finally by railroad to Jupiter. This circuitous and costly mail route took six to eight weeks each way, covering about three thousand miles. Thus, the barefoot mailman delivery system was initiated and lasted for a brief period until a more efficient system could be developed.

James Hamilton was one of the barefoot mailmen. He received $650 annually for his work. He walked the route on sand with the mail and whatever provisions he could carry. He had to sleep on the beach or in government-built refuge houses at night. He also lived off the land, eating fish and vegetation that were plentiful along the way. In 1887, Hamilton met his fate when he arrived at the Hillsboro Inlet. His routine was to

The Foundation Years

A statue of the Barefoot Mailman is located at the Hillsboro Beach town administration building on State Road A1A, north of Pompano Beach. He delivered mail on foot along the beach. *Author Collection.*

hide a skiff in the brush and retrieve it to cross the waterway. On October 11 of that year, upon arriving at the Hillsboro Inlet, his small boat had been taken to the other side. He placed his mail pouch on a tree and attempted to swim to get his boat on the other side of the inlet. James Hamilton was never found. He either drowned or was killed by an alligator or shark.

James Hamilton, the Barefoot Mailman, has been celebrated in many ways. The post office substation on Riverside Drive near Atlantic Boulevard, was named after him in 1956. It was torn down in 2004 to make way for the luxury high-rise Oceanside condominium-hotel, which replaced the old, outdated Oceanside low-rise shopping center at Atlantic Boulevard and State Road A1A. Theodore Pratt (1901–1969) wrote a popular historical novel based on the incident, *The Barefoot Mailman* (1943). Pratt cited a plaque that was placed at the inlet:

> *In Memory of James E. Hamilton*
> *U.S. Mail Carrier, Who Lost His*
> *Life Here In Line of Duty, October 11, 1887*

The Hillsboro Lighthouse is located on Hamilton Island, a tiny three-acre coast guard station, which extends from the Hillsboro Inlet north to Boca Inlet. It is not open to the public. Longtime residents remember when the inlet was used as a swimming

hole. Hollywood produced a movie in 1951 starring Robert Cummings and Terry Moore that was based on the Pratt book. The movie was filmed in Naples and Silver Springs, Florida. The Barefoot Mailman has been honored in other ways: a hotel existed at the northeastern part of State Road A1A where a condominium now exists at 1061 on Hillsboro Mile; a plaque stands at the Hillsboro Lighthouse; murals in the West Palm Beach post office depict scenes of the mail being carried along the Florida shores; and a statue is located at the administration building of the Town of Hillsboro. The barefoot mailmen were replaced by the extension of the railroad southward to Miami. The beach-walking postmen remain a colorful part of the history of the region.

As part of Pompano's Golden Jubilee celebration April 13–18, 1958, twenty-two-year-old Glen Courson, a stand-in for a barefoot mailman, replicated a segment of the east coast mail route. Courson left the Hillsboro Inlet with a mail pouch, crossed the inlet by rowboat, picked up the mail at the Pompano Beach post office on State Road A1A at 10:00 a.m., made his first delivery at Lauderdale-By-The-Sea at 2:00 p.m. and walked the entire route to Miami, being cheered on by dignitaries and well-wishers. Courson, however, did not sleep on the beach en route to his destination; he took a room at the Yankee Clipper Hotel in Fort Lauderdale and one at the Americana Hotel in Bal Harbor.

Pompano Beach marks the northern boundary of the Florida reef. At this boundary lies the Hillsboro Inlet—the water outlet to the Atlantic Ocean. The inlet is named for the Earl of Hillsborough (1718–1793), now spelled "Hillsboro," who owned a large tract of land in Florida and served as secretary for the colonies. The historic Hillsboro Lighthouse at the inlet stands majestically to the north of city. Seeing the need for a lighthouse to guide ships on the Atlantic Ocean between Jupiter at the north and Cape Florida at Key Biscayne to the south, the United States Congress appropriated the sum of $90,000 for a lighthouse to be constructed at the inlet. The Hillsboro Lighthouse began operating in 1907. Its first keeper was Alfred A. Berghell (1907–1911) who was assisted by two other keepers. They and their families lived in what amounted to isolated and primitive conditions on the north side of the inlet, where wooden shelters and service structures were built. Berghell was born in Finland, graduated from the Russian Naval Academy, was an experienced sea captain, came to the United States and worked at several lighthouse stations before working at the Hillsboro Lighthouse.

There are thirty-two operating lighthouses today that rim the Florida coastline. In 1932 the Hillsboro Lighthouse became electrified, one keeper position was eliminated and one of the cottages was purchased by the Hillsboro Club. Since 1939 it has been the responsibility of the United States Coast Guard to keep all the lighthouses functioning. The practice of the traditional lighthouse keeper who lived on-site and regularly polished the lamps ended in the 1960s. Lighthouses are now turned on and off by photocells and electric timers. The height of the Hillsboro Lighthouse is 136 feet above water, and it is one of the tallest in the state. The St. Augustine Lighthouse is the tallest at 161 feet above sea level. In 1979 the Hillsboro Lighthouse was listed on the National Register of Historic Places.

The Foundation Years

The private Hillsboro Club Resort (looking south) lies north of the Hillsboro Lighthouse and provides luxurious amenities for its guests. *Florida State Archives.*

There have been many famous visitors to the lighthouse. Secretary of State Edward Stettinius owned a home on the famous Hillsboro Mile. He brought President Franklin Roosevelt, Winston Churchill, British prime minister, and Anthony Eden, British foreign secretary, to the Hillsboro Lighthouse grounds. Others who visited the site to relax were World War II heroes General Douglas MacArthur and Admiral Nimitz. Because fishing and boating are very important recreational and economic pursuits, Pompano Beach, with private funding subsidies, launched a project in 1949 to improve the navigability and safety of the inlet, which connects the Intracoastal Waterway to the Atlantic Ocean. The channel was deepened within the next decade.

Young New Englander Herbert L. Malcolm, with a Yale College degree, arrived in Florida as educator and headmaster at the Lake Placid School, an elite school for boys. Parents loved the environment so much that they persuaded Malcolm to convert the school into a private club that became the Hillsboro Club. Known as "Bert" to his friends, Malcolm was born in Australia when his father worked there for the Colgate Company. He soon took ownership of the school, bought a thousand feet of oceanfront land north of Hillsboro Lighthouse that extended to the Intracoastal Canal (Waterway), erected two buildings and moved the school from Coconut Grove to Pompano in 1925. Roads and bridges were lacking then, and parents and students reached the

★ KEEPERS OF THE LIGHTS ★

1907-A. BURGHELL	1969-D.H. STEERMAN
1911-T. KNIGHT	1972-D.W. PARTRIDGE
1920-J.B. ISLER	1978-L.M. JACOBSON
1939-B.F. STONE	1981-M.B. SUTTON
1943-W. BENNETT	1984-J.S. VOSBURGH
1951-H. KANDORE	1986-T.M. GOLEMBESKI
1954-J.S. CHILDS, JR.	1989-M.D. HELMS
1955-J. MILLER	1993-L.G. JESSE
1956-F. EDELKAMP	1997-D.L. SPARKENBAUGH
1957-F. TUCKER	1998-R.H. KOGER
1959-J. EVDOKIMOFF	1998-A.A. MAKENIAN
1961-D.F. THURSTON	
1962-F. WARREN	
1966-J.D. LLOYD	
1968-J.T. RODGERS	

Early keepers of the Hillsboro Lighthouse lived in isolation on Hamilton Island, which is named for the barefoot mailman who drowned crossing the Hillsboro Inlet in 1887. All keepers are listed here. *Author Collection.*

school by boat. Two years later Malcolm remodeled the buildings into hotel rooms and accommodations for sixty guests. The enterprise became so successful that by 1960, over 225 guests could be cared for with a staff of one hundred and thirty. It continued to provide an extraordinary experience for members and guests. It is not unusual for families to be Hillsboro Club members for several generations.

The Hillsboro Club became the oldest resort in the county, a self-contained community located at the base of the Hillsboro Lighthouse with a thousand feet of private beach. It sits on its own peninsula with a private entrance. Today there are ten tennis courts, a beautiful eighteen-hole pitch and putt golf course, a regulation croquet lawn, nurseries, lush vegetation, instruction in arts and crafts, childcare, a spa and fitness center and a pool and nautical sports. Malcolm made certain that his guests were pampered so that they would return the following year. As a private club with high expenses, guests were among the upper class of society. Malcolm was active in local affairs, contributing his time and efforts to the success of the Pompano Rotary Club and St. Martin-In-The-Fields Episcopal Church.

As a part of the tourist industry, charter boats are a popular way to enjoy seafaring and fishing. Captain John J. Whitmer is recognized as the first charter fisherman at the Hillsboro Inlet Marina. He knew every species of fish and was an expert angler. Those individuals who accompanied him on his charter tours were confident that he knew where the best fishing was in the Atlantic, and they were assured that he put their safety first.

The Foundation Years

The Hillsboro Lighthouse Stamp Collection Dedication Ceremony was held at the Hillsboro Inlet on June 16, 2003, with the issuance of a $0.37 stamp and a stamp plate displaying all twenty southeastern lighthouses. *Author Collection.*

Because of its early development and rich history, Pompano has been traditionally associated with the Hillsboro Lighthouse. The Lighthouse Preservation Society and the U.S. Coast Guard jointly sponsor annual tours of the Hillsboro Lighthouse station. Because the station is on a tiny peninsula with limited space for parking, the tours are conducted by boat or bus and begin and end at the Pompano Beach city parking lot on North Riverside Drive. On March 7, 2007, on the south side of the Hillsboro Inlet, east of State Road A1A, the one-hundredth anniversary of the lighthouse was celebrated with fireworks, guest speakers and a birthday cake.

2.
The Early Settlers

A plaque stands at the base of the Pompano Beach historical monument on Sixth Street that honors the pioneer families who planted the seed that would blossom into a vibrant city. It states:

> *This monument is dedicated to the memory of those men and women, known and unknown, who came to this area between 1896 and 1921. These pioneers came to farm or engage in commerce in the Pompano Settlement. They chose to make their home in this warm place of rich soil, abundant fish, pines, palmettos, alligators and mosquitoes. They were in many ways a diverse group, but all had the determination to endure the harsh conditions. Each pioneer family was very important in our history and contributed to the development of Pompano Beach. It is said that a railroad surveyor gave the name "Pompano" to the area in honor of the delicious fish he had eaten here. The Town of Pompano was incorporated in 1908, and became the City of Pompano Beach in 1947. The Pompano Historical Society dedicated the plaque May 29, 1999, with Donald Downie, Eldes Walton Whitsett, Mercelene A. Rutledge and Cornelius Rolle as co-chairpersons.*

A stagecoach provided an expensive service for travelers between Lake Worth and Miami in the 1890s; and the two-day trip was uncomfortable on the unpaved Military Trail. Thus, completion of the Intracoastal Waterway in 1890 and the railroad in 1896 set the stage for the beginning of Pompano as the earliest settlers began to arrive. George O. Butler, Frank Sheene and Jim Pierce, surveyors for the Florida Coast Line Canal and Transportation Company, came in 1896 to survey and plot the thousands of acres of land that had been given to the company for building the East Coast Canal, as it was called at the time. Sheene is credited with naming the area Pompano after having eaten the delicious saltwater fish, which was then in abundance. The name stuck. These pioneers, along with others to follow, decided to build a community around Lake Santa Barbara. This pristine area was lush with vegetation and wildlife. The first child known to be born in Pompano was Franklin Sheene Jr. in 1901.

Longtime Broward County resident Cooper Kirk conducted an interview with eighty-five-year-old Elizabeth J. Warren in 1980. She lived at 19 Northeast Fifteenth Avenue,

Pompano Beach

In the first decade of the twentieth century visiting ministers provided religious services to gatherings of all faiths in the Pompano Community Church as seen in this image east of the railroad station. *Betty Johnson.*

Pompano. A widow of Lucius Warren, she was born in 1895 at Hypoluxo, Florida. She was four years old when she moved to the area with her parents, four brothers and sister. Her parents were originally from North Carolina. The Model Land Company, owned by the Flagler Railroad, was encouraging people to settle in Pompano. The Warren family migrated by boat with all their belongings, coming out of the canal at Cypress Creek and settling at Lake Santa Barbara, also called Lettuce Lake and Hardy's Lake. Surveyors had preceded them. There was a little house there to sleep and the family cooked under a palmetto shed.

The Warren males began farming for a livelihood, producing string beans, tomatoes, peppers and other vegetables. The women remained at home. The family subsisted on fishing, hunting and their garden harvests. There was no church. Elizabeth Warren remembered that the first religious services took place in the family living room or in the schoolroom. A traveling preacher would arrive and stay for a week. Years later, in the early 1930s, her husband was active in the Masonic Order and she was a charter and life member of the Pompano Chapter of the Order of the Eastern Star. Perennial presidential candidate William Jennings Bryan came to Pompano in 1912 to deliver a speech for the dedication of the women's club building. Henry M. Flagler was instrumental in getting Bryan to speak. His railroad transported many people from Miami and Fort Pierce who wanted to hear Bryan.

The Early Settlers

There was considerable cordial contact with the American Indians. They camped on the edge of Lake Santa Barbara near the Warrens and hunted and fished throughout south Florida. As the agricultural industry became profitable, the Native Americans, mostly the women, would come to pick vegetables. Fifteen or twenty would arrive in a group, cut down trees and make shelters with palmetto limbs. They were paid in cash. The Warren family also traded vinegar, flour, sugar and meal with the Native Americans for venison. Elizabeth and her brothers and sister often rowed boats and swam to the Indian Mound located off State Road A1A at Southeast Thirteenth Street.

Lake Santa Barbara was also called Lettuce Lake because the vegetation growing in the surrounding area was similar to lettuce. It was also known as Hardy's Lake, named for Isaac Hardy and his wife Catherine who had moved their family on a raft down the Intracoastal Waterway in 1899 from Hypoluxo, and who built a house at the lake. Hardy farmed vegetables and traded with the American Indians who poled down Cypress Creek. They traded calico and flour for fruit and meat. The Hardy house was built on a forty-acre tract of land he purchased for $240. In 1908 a fire destroyed his homestead, but he quickly rebuilt from the ground up. The family boasted three girls and four boys.

This community emerged as West Pompano at Southeast Sixth Street and Lake Santa Barbara. Mrs. George Butler opened the first school with twelve students in 1897 on the west side of Lake Santa Barbara, near what is now the Pompano Beach Cemetery. The one-room schoolhouse was destroyed by a hurricane in 1903. George Butler managed the first post office in his home in 1899.

In the same year that L.R. Smoak arrived with his wife and their son and daughter, Harry McNab, his brother Robert and his sister and mother also settled in Pompano. They had the vision that land would be the basis for prosperity in this period as they engaged in agriculture, and they accumulated a considerable amount of this natural resource. In fact, agricultural pursuits became the most important enterprise that led to prosperity.

The challenges were many as these pioneers confronted the intense heat, occasional destructive hurricanes, danger of wildlife, the horseflies and the mosquitoes. The horseflies were so thick that farmers had to build fires with palmetto roots to keep the pests off their mules, stated settler Tom Banks. And the mosquitoes! They were worse because of the danger of malaria. Banks recalled an incident in which a man who became unconscious outdoors due to alcoholism was found dead the next day from hundreds of mosquito bites. Roland Hardy, son of Isaac, stated, "Mosquitoes were so thick at Pompano in those days you had to scrape them off your arms." He also recalled that the early settlers either walked or rowed a boat to get to their destinations. Also, when a farmer went off to work in the fields, he left a rifle with his wife to fend off possible marauding wildlife.

December 1895 and January 1896 marked the occasion when the citrus industry was hit by the severest freeze in north central Florida. The frost forced the citrus farming industry to move south. It was a major setback, though temporary, for growers and their workers. It also accelerated population movement southward.

Pioneer Robert A. McNab settled in Pompano in 1898. The McNabs originally were citrus farmers in the Orlando area, and they helped shape the development of Pompano Beach. *Betty and Dennis McNab.*

Built in 1925 on the south side of East Atlantic Boulevard on an isolated piece of land, the Robert A. McNab House survived the 1926 and 1928 hurricanes. The W. Harry McNab House is across the street. *Betty and Dennis McNab.*

The Early Settlers

In the early part of the twentieth century no one was concerned about the potential value of oceanfront property. Farming and small businesses predominated. Frank Mauldin ran the first dry goods store. Betty Warren's father built the first house in Pompano. Children roamed freely, leading a Huckleberry Finn type of existence. Everyone knew each other. Families would go eastward to the beach where fishing, boating and picnicking took place. A sense of community prevailed. If anyone died, all the shopkeepers would close for the day and the whole town attended the funeral.

John Andrew Saxon arrived in 1896 to work as a foreman for the Florida East Coast Railroad. He built a house on Old Dixie Highway. His forty-acre farmstead was located on land where present-day Pompano Harness Track is situated. Also in the same year, J.W. Smith and Mac Smith arrived to work as surveyors for the Model Land Company, which managed the sale of land for the railroad. They laid lines around Lake Santa Barbara east of what would become the present-day U.S. 1 Highway.

Emil Ehmann planted pineapples in 1897 and this crop prospered, at least for a while. He and other farmers soon learned that tomatoes, beans and peppers were more profitable to grow, and the pineapple business died off. Ehmann soon extended the farm to land where the airport, golf course, homes and the city center presently exist. The early farms laid the foundation for a growing agricultural economy. Truck farming developed as Pompano would become the world's largest winter vegetable market because of the rich land and because of the diligent hard work of the early settlers. L.R. Smoak moved into the settlement in 1899. Recognition of the agricultural origins of Pompano can be seen today in the names of roads named for the original farmers: Blount, Hammondville, Lyons, McNab, Sample and Wiles.

There was a group of pioneers who called themselves the "Ninety-Niners" because they arrived in Pompano before 1900, or were married to someone who did. They met annually. By 1961 their numbers had been reduced to Mrs. W.H. McNab Sr., who had come as a bride in 1912 and was the widow of the organizer of the group; Mrs. Roland Hardy; Mr. and Mrs. George Wright; Mr. and Mrs. Eugene Hardy; Mr. and Mrs. Lucius S. Warren; and Mrs. Oscar K. Johnson. During the 1961 meeting, Mrs. McNab remembered the all-day horse-and-buggy outings to Fort Lauderdale. These trips started at 7:00 a.m. and took two and a half hours to get there. Mrs. Johnson pointed out that as a resident of Pompano she had lived in three counties without ever having moved.

The coming of the railroad began to shape Pompano. Life continued to be difficult in these early years as the comforts of modern civilization were nonexistent. Callie Johnson, daughter of J.W. Umsted, related her experience when she arrived in 1899 at the Florida East Coast Railroad station. The family had to wait at the depot the entire night for the wagon to pick them up and transport them to their home at 213 Northeast Tenth Street. Atlantic Boulevard was then a narrow dirt road. Callie Johnson's sister remembered what life was like then:

> *We placed our meat orders on the freight train to West Palm Beach. Merchants there packed as much meat as possible in with a 100-pound cake of ice in sawdust. Canned goods were ordered from Jacksonville, because there was no road to the beach and a little*

dirt trail where present-day Atlantic Boulevard is now, we would ride a horse or a mule and then take a barge across what is now the Intracoastal Waterway.

J.H. Chapman built a packinghouse five years later. Modern machinery was lacking for the farmers. Drainage was inadequate, with flooding being a common occurrence. The settlers persevered. And yet, people continued to arrive.

William H. Blount vividly remembered his experience upon arriving in 1907:

When I arrived in Pompano on a February night in 1907 at about ten o'clock, the conductor blocked my exit. He insisted that I go on to Miami because there was nothing in Pompano and nowhere to stay. The conductor claimed that Pompano was a wild place. But the lure of a job which paid twenty dollars a month plus board was too strong. My brothers J. Devotie and George, who had preceded me the month before, met me at the depot with horse and wagon. Pompano had no paved streets…Dixie Highway was a white-rocked thoroughfare not more than nine feet wide. There were no cars…Although the lighthouse had been built, there were no houses along the beach. Our farm holdings were pretty much scattered as we had to take the best land where we could find it. Tomatoes were the big crop…At first, the tomatoes had to be shipped green, but within two years of my arrival, we were able to ship the tomatoes in refrigerated cars.

The Blounts, brothers George, Devotie and William, worked hard all year and became successful as they farmed more than two hundred acres of land in the 1920s. During the planting season of 1920–1921 they produced and sent fifteen thousand hampers of beans to northern markets. Other crops included eggplants, peppers and tomatoes. They plowed the land, seeded and harvested the crops. William H. Blount commented, "Many of our field hands came from Nassau. To have a crew of ten or fifteen was a crowd." Brother George had arrived in 1906 attracted by the opportunity of prospering in the farming business; he persuaded his two brothers to follow him to Pompano. The Blounts also engaged in real estate development and prospered in this business. They donated twenty-three acres to what became the State Farmers Market. Blount Road exists today in Broward County. The Blount brothers bought all four corners at Northeast Fifth Avenue and Sixth Street and each brother built his own house on three corners, while the extra lot was kept as their own park.

Hiram F. Hammon never lived in Pompano, but he did play a part in the development of the surrounding area. He came from Conneautville, Pennsylvania, in 1868, and settled in what is now Palm Beach. He began to buy large tracts of land for farming west of Pompano. The town of Hammonville emerged, originally inhabited by employees of the Hammon Development Company. Following the death of Hammon, company trustees Horace P. Robinson and Wallace Robinson guided the agricultural business, eventually selling out to a group of investors. During the early years Hammon Road was the only westward link with State Road 7 and U.S. 441, actually the same route. Later, Hammon Road was changed by mapmakers to Hammond Road, then to Hammonville Road and to Hammondville Road. Martin Luther King's name was added atop Hammondville

The Early Settlers

Road signs in honor of the martyred civil rights leader. Today Margate stands where Hammondville once existed.

George Sterling McClellan was Pompano's first resident physician, opening an office at Northeast First Avenue and Second Street. He was a graduate of the Eclectic School of Medicine in Atlanta, Georgia, and relocated to Pompano in 1921. His wife served as his nurse and ran his office. Dr. McClellan charged $2.00 for an office visit and $5.00 for a house visit. He was a charter member and president of the Broward County Medical Association, served three terms on the Florida State Board of Examiners and helped to establish the Broward Medical Center and the Holy Cross Hospital. His office was in a building that was constructed of reinforced concrete made with steel; it withstood the 1926 hurricane, providing shelter for six local families.

Ora L. Jones's *Historical Souvenir Program, 1908–1958* that was produced to celebrate Pompano Beach's Golden Jubilee lists some of the other early settlers who helped lay the foundation for the future growth. These individuals deserve recognition: J.W. and Pink Pierce; Emmett Rogers; Joseph Neeley; J.K. Howell; Samuel K. Slaughter; Cap Campbell, who later was elected mayor; G.D. Wyse, who served as president of the city council; Mrs. Wyse, who served on the city council and taught school; David Smith; Walter Smith; Church L. Lyons and his sons H.L. and Clinton Lyons; A. Osteen; A.N. Sample; A.W. Turner, who served as the first sheriff of Broward County and on the city council; A.E. Harry; "Uncle Steve" and Robert Humphrey; Frank W. Austin; Dudley Woods; Section Foreman Star Hamilton; Lee Spears; James McComb, who built and occupied the home west of the office of Dr. George S. McClellan; J.W. Harper; W.H. Shuford; G.A. Kunz who planted the large banyan tree on Old Dixie Highway; J.A. Howell; Carleton Marshall; W.E. King; J.W. Rouse, whose home stood on the site of Hamilton's Pharmacy; Richard Rowe; Joshua and Frank Simmons; Joseph and O.J. Skates; Section Foreman Thomas Hamilton; W.B. Cassells; the Ritter family; Thomas Sumpter; Colonel Hinson; John and Lucius Warren; Roland Pike and his sister Sherbie; W.A. Pagan; Alva Hosford; M.T. Whidby; the Gould Smith family; W.H. Raines; C.E. Haile; D.D. Grant and William Grant; T.V. Osteen; the Griffin family; the Windham family; the J.B. Snell family; D.L. Drawdy; Joe Wilkinson; and J.B. Ashley, the brother of notorious bank robber John Ashley.

Florence Major Ali was born in 1898 in the Bahamas, moved to Cuba where she resided for five years and finally made her permanent home in Pompano in 1911. She married Cuban-born Frank Ali, but they divorced in 1953. As an enterprising black leader she designed fashionable clothing and worked as a seamstress and in the restaurant and real estate businesses. In the World War II era she organized the Negro Beauticians of Broward County and fought successfully to have the county appoint black inspectors to regulate black beauty and barbershops. She hosted such black performers as bandleader Cab Calloway, dancer Bill Robinson and trumpeter Louis Armstrong, who were not allowed to stay at the hotels where they worked because of segregation laws. As a prominent leader in the community, the city commission appointed her to the Pompano Beach Community Relations Board in 1967. She was among the pioneers of Bethel A.M.E. and Mount Calvary churches and encouraged joint participation between

the two churches. She contributed financially and administratively to many community projects such as the YMCA, Variety Children's Hospital, Sunland Training Center for the Retarded and Martin Luther King drives. Florence Major Ali died in 1982.

Hazel Armbrister, a retired schoolteacher and civic leader, remembered the house in which Florence Major Ali lived that stood at 357 Hammondville Road (also named Martin Luther King Boulevard). It was built in 1933. The area was alive with economic and social activity. The Ali Building, as it came to be known, was the center of that activity, and it remains as the only physical reminder of years gone by. It is an example of commercial vernacular architecture. In 2007 the Ali Building was slated for demolition, although Armbrister and the city commissioner E. Pat Larkins attempted to save it because of its historical significance, hoping to convert it into a black museum to honor the pioneers who built the town. The Hammondville Road neighborhood is part of a redevelopment program as part of the Western Community Redevelopment Agency.

Jack Swain also is credited with enriching many lives in Pompano. He was born in 1880 in Georgia, moved to Callahan, Florida, and then south to Pompano. In 1904 he married Nella Rhone. Two years later he worked as a sharecropper on the A.W. Turner farm. At the end of the agricultural season he returned to Callahan to be with his family. This routine was continued until 1909 when he moved his family permanently to Pompano. Swain became a member of the Mount Calvary Baptist Church the following year and was ordained a deacon by Reverend J.T. Brown in 1914. The next year his wife was converted and baptized by Reverend Lawrence J. Ely. The Swains had eight children: Iola, Earnest, Louis, Bernice, Rufus, Willie, Mildred and Myrtle. Deacon Jack Swain died July 20, 1947.

Reverend Lawrence J. Ely, father-in-law of Blanche General Ely, provided spiritual guidance to his flock at Mount Cavalry Baptist Church. He served as pastor there from the early 1900s to his death in 1918. His wife is credited with being the first black midwife in Broward County at a time when midwifery played an important role in healthcare.

It is impossible to list all the achievements of Blanche General Ely (1904–1993). She was born in Reddick, Marion County, Florida, to Deacon John W. General and Sarah Enock General. Her mother died before her second birthday, and her father and stepmother, Amanda Ward Givson General, reared her. She was baptized in the Baptist faith in Reddick. Her family moved to Deerfield, then to Pompano where she joined the Mount Olive Baptist Church. She earned a bachelor of arts degree at Florida A&M University in Tallahassee and a master of education degree at Columbia University in New York City.

Blanche Ely was appointed principal of the school, which she saw grow from a two-room building on Hammond Road to what became the Coleman Elementary School. In 1954, after the high school was built in Northwest Pompano, graduates and others fought successfully to have the school renamed Blanche Ely High School in her honor. As an educator she emphasized academic programs and nourished young teachers and administrators to continue her work. She sent many talented students on to college and to successful careers in business and the professions. She was instrumental in securing

The Early Settlers

Blanche General Ely was an educational leader in Broward County as principal of Ely High School. She dedicated her life to improving the educational system for black students. *Eunice Cason Harvey.*

Joseph Ely, husband of Blanche General Ely, was principal of Dilliard High School in Fort Lauderdale, and later principal of Crispus Attucks High School in Dania. He was also a leader in the civil rights movement. *Eunice Cason Harvey.*

funding for the Migrant Housing Project where a school was built, and from it emerged the Markham Elementary School. A housing project for low income families was named Ely Estates. Northwest Sixth Avenue was named for her. As an educational leader, she faced many challenges because black students attended school for only six months out the year, from June to December, until as late as 1951. The students worked part time

and full time on the farms. She and her husband, Professor Joseph Ely, sponsored the first federally funded lunch program in Broward County.

She received numerous honors and awards. Some of the most important ones were: NAACP Award for Outstanding Service; 100 Black Men Award; Greater Pompano Beach Council Award; Broward County Historical Commission Award; Pioneer in Education from WSVN; and Iota Sorority Service Award. And her former students honored her with reunion celebrations. The Blanche Ely Museum in northwest Pompano Beach is a monument to her contributions to education in Broward County. Blanche General Ely died December 23, 1993, and interment was at Forest Lawn Cemetery, Pompano Beach.

Another outstanding leader in this early period was Reverend James Emanuel Coleman, who was always accessible to his flock and a spokesman for the black community. He was born on November 16, 1873, in Thomasville, Georgia, the son of a former slave. Rejecting a farming career that his father engaged in, he studied to become a minister. He was ordained at the age of eighteen. His ministry began in Georgia where he served two Baptist churches. He relocated to Miami in 1920 where he served at St. Mark's Church. He moved north to serve simultaneously at the Deerfield Mount Zion Church and Pompano's Mount Calvary Baptist Church where he alternated preaching on Sundays. He ministered to mostly farmworkers who had little voice in the community.

As pastor of the Mount Calvary Baptist Church from 1923 to 1946, Reverend Coleman fought for his people to get the benefits that were denied to them in housing, work and education. In an age of discrimination, he believed that education was vital in the battle for equal rights and social mobility. Black children attended schools for fewer than the required 180 days because they had to work during farming season. Thus, the schools were not accredited and did not reach the level of the schools for whites. One of his parishioners was Blanche General Ely, and together they worked to improve the educational system. Reverend Coleman suffered a stroke in 1949 and died on August 25, 1958. The Coleman Elementary School was named in his honor in 1954; it was phased out later when integration took place. Coleman Park is on the site that was once the Coleman Elementary School.

A booklet, *Making History Together at Mount Calvary Baptist Church*, was published in 1983 and described the contributions that black family pioneers made to the community. Educational leader Eunice Cason Harvey chaired the project, and Reverend Otis L. Sample Jr. was pastor. Harvey pointed out that "segregation was very much in effect" in the early years. Housing was deplorable. Some "farm lords" built small houses called "quarters" for the black farmworkers to live in.

Laws were unequal, and bigotry was clearly shown. During the 1930s, racial tension was high in Pompano. It was shown in all aspects of the Black community…During the 1930s, racial tension was high in Pompano. An injustice similar to the Scottsboro Case in Alabama occurred in Pompano. Men illegally searched houses of Blacks and accused them of crimes. It was rumored they were going to burn out the Black community. Many

Blacks left Pompano and did not return. There was a great deal of mean feeling during this period of time.

In spite of these issues, Harvey praised white citizens who made contributions to Mount Calvary Baptist Church and to the school: the Blounts, Lyons brothers, Joneses, Wesley A. Parrish and Drs. George McClellan and S.A. Winsor. She did admit that the successful pioneer white farm leaders were farsighted in recognizing the potential of the rich earth of Pompano. The booklet cited positive examples of the achievements of black families in Pompano. In 2007 the Mount Calvary Baptist Church celebrated one hundred and five years of religious service.

Jonathan Rolle arrived in Florida by boat from the Bahamas in 1908. He and his wife established the foundation for a loving family of eighteen children, several of whom died. He worked as a truck farmer, laid tracks for the Florida East Coast Railroad and took whatever jobs were available. Central to the Rolle family legacy was hard work, discipline and caring for others. Daughter Esther, who became an actress of great renown, was born in a "section" house owned by the FEC Railroad. In the late 1930s the older sisters and brothers formed a theatrical group called the Family Circle to entertain the younger children, and then performed original plays at black churches and lodges along the east coast of Florida. Older sisters Estelle and Roseanna and younger sister Blanche graduated from this group to become successful actresses. Their father, who was an effective storyteller and who possessed a dramatic flair, greatly influenced Esther. After earning a degree in education she began her career with an African cultural dance group. She became a founder of the Negro Ensemble Theater in New York, performed on Broadway and in movies and television. Esther received many awards, but she was extremely proud of the Emmy for her leading role as Florida Evans in the popular television series *Good Times*, in which she starred as a mother who espoused traditional middle-class values with a strong sense of family.

According to Jonathan Rolle's son Cornelius, recalling the "little Scottsboro" incident of 1930s Pompano, "My father was very strict…He didn't feel subservient." Once during World War II, a white woman at the Broward driver's license office addressed father Jonathan as a "boy." Cornelius said his father replied vehemently, "I am six feet four inches tall and I weigh 218 pounds. I have thirteen children and two sons in the service. How can you get a 'boy' out of that?" Jonathan was a dedicated pioneer of the Mount Calvary Baptist Church, the first clerk, organizer of choir number one, a deacon, superintendent of Sunday school and Baptist Training Union and worked in all other areas of the church. Janice Rolle, daughter of Cornelius, has been Pompano Beach librarian for many years.

Invited to her hometown, Esther Rolle was honored on March 16, 1981, by the City of Pompano Beach Northwest Federated Women's Club and Sigma Gamma Rho Society. Earlier in the day she spoke at Deerfield, Dilliard, Pompano Beach and Ely high schools, encouraging students to study and strive for success. She remembered harvesting vegetables as a child alongside her brothers and sisters and attending school in the off-season. Northwest Third Avenue at Northwest Fifteenth Street was renamed

The Early Settlers

Famous actress Esther Rolle was a Pompano native who starred in the television program *Good Times*. She is buried in Westview Cemetery. The Rolle family members continue to be active community leaders. *Janice Rolle.*

"Esther Rolle Avenue" during a ribbon-cutting ceremony led by Mayor Emma Lou Olson. Hundreds assembled at Mount Calvary Baptist Church after a parade from Ely High School along newly named Esther Rolle Avenue. Overwhelmed with emotion she said:

Travelers admire the W. Harry McNab House, built of yellow brick in 1925 on the north side of East Atlantic Boulevard. It is identical to his brother's home on the south side. *Author Collection.*

That little old me could have such an honor bestowed on me in my own hometown is such testimony. That which you get at home has a special meaning of love and warmth.

She is buried at the Westview Cemetery on Northwest Fifteenth Avenue between Powerline Road and Copans Road. To cite another Rolle family member, Esther's brother Isaiah Cornelius Rolle also was a community leader and his daughter-in-law Janice Rolle has given outstanding service as a leader of the Friends of the Library, children's librarian, founder of the northwest branch library and librarian at the Pompano Beach main library

Another resident who appreciated the intimacy of close relationships in the early years was Ethel Bebe Delk. She was born in 1925 to Harvey S. and Georgia Collier Cheshire. The population of Pompano had reached 2,614 in 1930. Of the total, there were 1,487 blacks and 1,127 whites. Following graduation from Pompano High school, Ethel Bebe Delk continued her education at Stetson College for two years. Her family was deeply involved in community life through the ownership of a producer brokerage business at Pompano State Farmers Market for forty-eight years. She is a local rarity because she is a fourth generation Floridian. Her marriage to James G. Delk produced three children, two girls and a boy.

T.C. Davis has witnessed Pompano Beach grow from dirt roads to modern highways that became a part of the interstate highway and Florida Turnpike transportation systems. He has experienced the changes that Ethel Bebe and James Delk have experienced. Davis was born in Pelham, Georgia, in 1919. His parents arrived first in Pompano, followed by three sons in the 1940s. They found housing in what was then

The Early Settlers

A historic marker identifies the W. Harry McNab House, which was purchased and restored by the Weissing Law Center. *Author Collection.*

known as the projects. Davis first worked on the farm owned by Bud Lyons in what is now Coconut Creek. He took agricultural work where it was available, following the seasons from Pompano, to New Jersey, to New York, to Maryland. Fieldwork demanded much physical labor, but he had to provide for his family, which consisted of his wife and twelve children. He left farming, was employed at Port Everglades unloading ships and was hired by the Bob Brown Construction Company doing masonry work until he retired. Soon after 1950 he purchased his first home for his family, one of his proud achievements. As the years passed, he saw his children go from attending the "colored" school to graduating from Pompano High School. The gains made in the civil rights movement were many. He has worked for, and benefited from, the election of Pat Larkins as city commissioner and mayor.

Following World War II the civil rights revolution would change American society, and Pompano Beach would feel that change. By the late 1970s pioneer black families had left the fields to see their children seek educational and professional opportunities. No longer would they experience the grueling demands of agricultural work, which started at sunup and ended at sundown for $1.00 to $1.50 per day. The only leisure time they had was attending church on Sunday and perhaps a picnic at the beach or park. At harvest time farmworkers received $0.20 to $0.35 a hamper. No longer would the black children attend school for an abbreviated period, typically from June to December under inferior conditions.

The completion of the railroad resulted in immediate changes. The center of the community shifted from Lake Santa Barbara to the area around the railroad station at Flagler Avenue and Northeast First Street. C.Z. Cavender opened a general store in 1900. Two years later the old post office was merged into a new one in the general store. A railroad house was built at Eighth Street. The commercial district developed as trade began and shipments of vegetables expanded, serviced by the railroad and later trucks. As the area grew to become Old Pompano, more and more people arrived from Georgia and northern Florida. Although the U.S. Census Bureau had announced the official closing of the American frontier in 1890 because of population growth in the American West, these early Pompano settlers were themselves frontiersmen as they overcame environmental challenges to produce bountiful harvests for their homes and families. They contributed to the expansion of the American democratic spirit. A proprietary pride exists today among the small number of their descendants.

3.

Boom and Bust

During its early history, Pompano has been part of three counties: Dade, Palm Beach and Broward. The city was originally within the boundary of Dade County until 1909, when it split off to become the southernmost part of Palm Beach County. The map specifying the change listed the towns of Pompano and West Pompano. Actually there was only one Pompano, and the listing of two Pompanos was caused by the fact that at the time there was a post office at George Butler's house at Lake Santa Barbara and one at M.Z. Cavender's store at Flagler Avenue and Northeast First Street. Because of the increasing growth of the region, Broward County was created on April 30, 1915, becoming the fifty-first county in the state. Woodrow Wilson was president and the United States had not yet entered World War I.

Pompano Beach is located in the northeastern section of Broward County and borders on the Atlantic Ocean, with the Intracoastal Waterway flowing north and south. It is a part of the Gold Coast. The 1920 U.S. Census recorded 639 people living in Pompano; 5,135 living in Broward County; and 968,000 living in Florida. To the west of Old Pompano at this time no suburban communities existed, only farmland. As time passed, the largest cities would become Fort Lauderdale, the county seat, Hollywood, Pompano Beach, Coral Springs and Plantation.

The Fort Lauderdale *Sentinel* lead story of April 23, 1915, announced that "Broward County Is Assured" when the bill passed through the legislature creating the new county. Fort Lauderdale was designated the county seat. At the end of the month a joyous crowd gathered in the streets in the evening as a band played and prominent community leaders delivered speeches. There had been a long battle led by factions lobbying to prevent the formation of the new county from parts of Dade and Palm Beach Counties. But this opposition was quashed. On April 30 the *Sentinel* stated that within the new county borders were "five small but thrifty and enterprising towns, namely: Deerfield, Pompano, Ft. Lauderdale, Dania and Hollywood."

The county was named for Napoleon Broward who served as governor from 1905 to 1909. He was born on a farm in Duval County in 1857, was orphaned at the age of twelve and worked in various occupations: logging, farming, fishing, piloting a riverboat and trading between Jacksonville and Cuba during the Spanish-American War (1898). He entered politics, was elected sheriff in Duval County, to the Jacksonville city council,

to the state House of Representatives and to the governorship. He was elected to the U.S. Senate in 1910 but never served because he died before his term started. As governor he issued the following proclamation, according to custom, by designating Thursday, November 29, 1906, as a day of:

> *Thanksgiving and Prayer.*
> *And I recommend to all the people of this State that on that day, in devout assemblies in their respective places of worship, and in glad gatherings around family firesides, they give thanks to Almighty God for the prosperity which fills our land with plenty, and for a civilization which endears and consecrates associations of home. And I further recommend that the people make ready for this festival with love, which binds all hearts and brightens all homes; and with charity, that blesses alike both the giver and the received, so broad that it shall reach its needy ones in the State.*

Such a proclamation reflected a sentiment quite distinct from that of modern society. For a politically elected official to express a "Thanksgiving and Prayer" in 1906 indicated its acceptability by citizens of Florida, and especially by those of Pompano.

Broward is best known for his controversial program to drain water from the Everglades that began at the New River and continued on to Lake Okeechobee. His intention was to open the Everglades to agriculture. Digging began for the Pompano Canal in 1912, and it was completed in 1916. Other canals such as the Cypress and Hillsboro followed. Though the canals were important, the project was not completed. The reclamation and drainage program did, however, contribute to the development of Pompano.

Marjorie Stoneman Douglas has been famous for her classic study, *The Everglades: River of Grass* (1947), for which she became a leader in conservation in seeking to protect this natural treasure. In *Voice of the River: An Autobiography* (1987), she stated that her father, as editor of the *News Record* in Miami, criticized Governor Broward for his program to drain the Everglades at a time when little was known about this valuable ecosystem.

With the beginning of Broward County, the stage was set to elect a sheriff. Pompano's Aden Waterman Turner was elected as a result of his victory in the primary at a time when the one-party system prevailed. Turner defeated three other candidates and received 295 votes, more than the combined total received by his opponents. Turner served as county sheriff from 1915 to 1922. In 1922 Governor Cary A. Hardee removed Turner from office because the governor charged Turner with not being tough enough in enforcing the law. Turner was born in Nassau County in 1865. He settled in Pompano in 1907 as a farmer and road contractor. He was a popular local elected official. Another Pompano resident, Isaac I. Hardy, was elected a county commissioner several months after Broward was created in 1915. However, Hardy died soon after on Christmas Eve, and George L. Blount Jr. filled his position.

The first settlers began arriving in Pompano in the 1890s from North Florida, Georgia and the Carolinas. Some of them immediately formed the First Methodist Sunday School in 1899 in a small wooden building near Lettuce Lake (Lake Santa Barbara) on the present city cemetery site. A teacher arrived from Miami. During the years 1907–1908,

Boom and Bust

The Foster Church Chapel was named for Reverend George Foster who served as pastor of the Methodist Church in Old Pompano. The first service was held here in 1939. It has been awarded a "Historic Preservation Designation." *Author Collection.*

a two-room community church was constructed for $400 at the present intersection of First Avenue and Atlantic Boulevard near the canal bank. It became the center of town activity and other denominations attended. Sunday school met in the afternoon at 2:00. Church services were conducted whenever a pastor was available. Reverend J.T. Bartlett was the First Methodist minister who arrived by train from Delray, where he was pastor, and soon began preaching once a month during 1909 and 1910. In 1912 the Pompano Methodist Church was organized under the ministry of Reverend H. Carter Hardin. It became part of the Dania charge. During the next ten years the church became part of the circuit part-time preaching assignments at Delray, Boca and Deerfield. Membership in the Methodist Church in 1922 had surpassed sixty congregants.

In addition to Reverend Hardin, who served the Pompano Methodist Church, were J.S. Brooke, Steinback, Gault, W.O. Trautman, A.H. Moore, E.H. Crowson and J.W. Jackson. In 1922 thirty new members joined as a result of a revival held by Reverend John I. Whitworth, under pastorate of Reverend W.O. Troutman. The church became a station under Reverend C.S. Gardner in 1925. The following year the original building was destroyed by the September hurricane. Religious services were temporarily held in nearby stores on Northeast First Street. A parsonage was started on the southwest corner of Second Street and Third Avenue and was then converted to a church. In 1928 the Women's Missionary Society was organized.

A major turning point occurred in 1937 when Reverend George Foster, fresh out of the University of Florida and Duke University where he was ordained a minister, became pastor of the Pompano Methodist Church. He formed a building fund that led to the construction of the new church in 1938–1939. It was a fine example of gothic architecture. The first service took place on Easter Sunday 1939. Bishop Arthur J. Moore dedicated it in 1941. The former church was converted back to a parsonage. The sanctuary became the Foster Chapter or Church Chapel and has received a "Historic Preservation Designation" by the city, state and national governments. It is the oldest church in Pompano Beach.

Continued growth led to many other developments. More land was purchased for expansion. An educational building went up. Membership reached 1,500 by 1954. A new sanctuary was built and the Reverend John Sikes conducted the first service there in 1958. Chairs had to be rented since the pews had not yet been installed. This church building has served the congregation since then. The day care center was opened in 1963 and later became the Child Development Center. A thrift shop was built. In 1990 the Family Life Center was opened to the members of the church and community. The growth of the Methodist Church has mirrored the growth of Pompano Beach.

Another religious institution that made its mark was the First Baptist Church of Pompano Beach, located at 138 Northeast First Street. It was established in 1915 and immediately became a vital part of the community for the next ninety-two years. The first pastor was Reverend S.P. Mahoney from Fort Lauderdale who served for three years (1915–1918). Under his spiritual guidance the following individuals became charter members of the church: Mrs. Ed Cook; Mrs. Rachel Hardin; Mrs. Kitty Hardy; Mr. and Mrs. A.J. McGaughy; Mr. and Mrs. W.A. Petsch; Mr. Cleve Rucker; Mr. and Mrs. R.B. Rucker; Mr. W.C. Rucker; Mrs. L. Smith; Mr. and Mrs. Joseph P. Smoak; Mr. and Mrs. L.R. Smoak; Mrs. E.J. Walker; Mrs. John Warren; and Mr. and Mrs. George D. Wyse.

Reverend Mahoney preached two Sunday afternoons a month for a salary of ten dollars a month. Within the next three years five new members joined the First Baptist Church: George L. Blount; William H. Blount, Lawrence Brown; Mrs. Eugene E. (Rena) Hardy; and Mrs. Wallace (Dorothy) King. Reverend Mahoney was replaced by Reverend B. Atcheson (1918–1919) who served as pastor in both Pompano and Fort Lauderdale and received a salary of twenty dollars a month for the part-time pastorate. The church asked the state mission board to help pay his salary. The first revival services were held in June 1920 for two weeks, and fifteen new members joined the church. In the late 1920s the pastor's salary was increased to $320 per year. The following year the congregation voted unanimously to build a new church.

Dr. J.P. Lee (1922–1933) became the new pastor of the First Baptist Church and in the first year of his leadership four lots were purchased on Northeast First Street at a cost of $900 for construction of a new church. In July the first services were held in the new facility and the First Baptist Sunday School was opened in Pompano. Earlier in the year the Women's Missionary Society was organized. The first adult and junior BYPUs and a Sunbeam Band were formed. In 1923 a pastorium was completed next to the church building. Sunday school attendance averaged eighty-two students. All indebtedness was

Boom and Bust

Groundbreaking for the new Methodist Church Sanctuary took place in 1957. Trustee Waldo Johnson, building committee chairman, Grady Singleton, and Reverend John Sikes joined the children's choir. The water tower has been removed. *Betty Johnson.*

paid off by the time the church and pastorium were dedicated in March 1924. Five additional lots were purchased for future development. The 1928 hurricane caused considerable damage to the church and pastorium, but most of the loss was covered by insurance. By 1929 the total assets of the First Baptist Church amounted to $35,000, church membership reached 231 and Sunday school enrollment was at 279. Such growth was remarkable due to the generosity and commitment of its members.

By 1954 there were more than nine hundred First Baptist Church members. In the 1970s the church converted two church-owned lots to parking areas and purchased a clinic building on Atlantic Boulevard for Sunday school use. Today that building serves as the preschool learning center. In 1979 the day camp was started for vacation programs and after school activities. Foreign missions and youth and adult ministries were successfully continued and expanded.

Other pastors who served at the First Baptist Church were: J. Max Cook (1934–1935); O.G. Tillman (1936); C.W. Tew (1937–1945); Charles W. Smith (1945–1949); J.T. Mashburn (1950–1953); Gay Harris (1953–1962); Mack R. Douglas (1962–1969); Robert L. Smith (1969–1984); Thomas B. Harris III (1985–1987); Kenneth Hall Smith Jr. (1989–1991); Robert C. Dominy (1992–1999); David M. Rice (1999–2003); and Ron Harvey (2005–Present). On May 1, 2005, the First Baptist Church of Pompano Beach celebrated its ninetieth anniversary.

The First Baptist Church on Northeast First Street celebrated its ninetieth anniversary in May 2005. The first pastor, Reverend S.P. Mahoney (1915–1918), preached two Sunday afternoons a month and received a salary of ten dollars. *Author Collection.*

The Nineteenth Amendment to the United States Constitution was proposed in 1919 and ratified a year later in August. It simply stated: "The right of citizens of the United States to vote shall not be denied or abridged by the Unites States or by any State on account of sex." The movement for women's suffrage began at the 1848 Seneca Falls, New York convention and gained momentum through the Progressive Era in the early twentieth century. Ironically, Florida had not ratified the Nineteenth Amendment when it became the law of the land, although the legislature did pass legislation that gave the right to vote to its citizens. The state legislature finally acted on May 13, 1969, when the state House and Senate passed a concurrent resolution symbolically ratifying the suffrage amendment, without the signature of Governor Claude Kirk.

In 1920 Mrs. George D. Wyse was the beneficiary of the suffrage reform movement—she became the first woman to be elected to the Pompano City Council. There have been few women who have served in elective roles in city government, and many years would pass before they assumed a leadership role. In fact, there have been four women who have been mayor: Alice Lindner (1960), Betty L. Wistedt (1977 to January 10, 1978, when Wistedt suffered a stroke during a commission meeting and J. Maxim Ryder replaced her as mayor); Emma Lou Olson (1976–1985; 1990–1997); and Kay McGinn (2003–2004). Wistedt returned to her position on February 10, 1978; she was undergoing rehabilitation at Holy Cross Hospital. She was defeated for reelection the following month. In October 1979, still paralyzed and in a wheelchair,

Pompano Beach's first woman mayor, Alice Lindner, presents certificates to the city's first police reserves. Other women who have been mayor of the city were Betty I. Wistedt, Emma Lou Olson and Kay McGinn. *Pompano Beach Library.*

Wistedt received a $30,000 settlement because of the stroke she suffered during the city commission meeting nearly two years earlier. The city agreed to the settlement, which was broken down into $19,000 compensation for loss of future earnings and $11,000 for medical bills.

Pompano remained a rural, undeveloped, sparsely populated community in the first decade of the twentieth century. The U.S. Census reported a total population of 269 in 1910, while the state counted 752,000 people. As late as 1922 when Grace Carson Odum settled in the town, she expressed strong feelings toward the community: "Pompano was the most god-forsaken place I had ever seen." A bridge that was cranked by hand operated over the Intracoastal Waterway in 1916. Pompano nevertheless was ready for its own government. On July 3, 1908, Pompano became an incorporated city. John R. Mizell became the first mayor. J.K. Peacock became council president. George L. Blount Sr. assumed the position of clerk. The council members were: E. Rogers, J.K. Howell, D. Smith and Aden Waterman Turner. Since Pompano was still a part of Dade County, Clerk Blount journeyed to the Dade County Courthouse to file the official papers of incorporation. The town of Dania (Beach) is the oldest city in Broward County, having

been incorporated in 1904. Pompano Beach is the second oldest, and Fort Lauderdale is next, having been incorporated in 1911.

The council's early official records have been lost. Fortunately, other records have been found that provide interesting insight into the culture of the period. The Historical Souvenir Program 1908–1958, compiled for the city's fiftieth anniversary, chronicled various ordinances that regulated personal behavior and conduct. One ordinance outlawed begging, unlawful games, drunkards, nightwalkers, brawlers, thieves, rogues, vagabonds, stubborn children, common fiddlers, unemployed persons, vulgar speech and activity and persons who do not support their families. A fine up to fifty dollars and/or imprisonment up to thirty days would punish those convicted. Another ordinance prohibited owners from allowing their stock to roam the streets. A poll tax was established as a prerequisite for voting. (Florida abolished the poll tax in 1937.) The following "blue law" relating to public and private morality was passed in 1912 and stated that anyone who "follows any pursuit, business or trade on Sunday" would be fined up to fifty dollars. Sports activities were outlawed. In 1913 persons younger than twenty-one years of age had to be off the streets at 8:00 p.m., and registration of automobiles was now required. In 1915 all males were assessed one dollar per year to provide for a street improvement fund (road construction). The following year the city borrowed $5,000 to construct the council chambers and a jail.

In September 1924 the Pompano *News* began publication—a first in the city. The Seaboard Railroad began operation in 1926; it was one mile west of the FEC Railroad. High school students were transported by bus south to Fort Lauderdale High School. Pompano's first thoroughbred racetrack, built to accommodate seven thousand fans, was opened in 1926 on the grounds of the present-day Pompano Harness Track at a cost of 1.25 million dollars; it provided stables and service buildings for one thousand horses. The track was a one-mile oval, one hundred feet wide and surfaced with sand and clay. It appeared to be successful with a huge crowd present. Jockey F. Weiner won the first race at five and a half furlongs, paying $16.40 riding Cora Russell. But Governor John Martin closed the track the next day because parimutuel betting was illegal. He referred to Pompano as "a center of lawbreakers." In 1931 the state legislature legalized parimutuel wagering for dog and horse tracks. The original track continued to function intermittently through the 1930s and 1940s with auto racing and boxing matches.

An examination of the complete directory of the 1927 Southern Bell Telephone Company is revealing. It consisted of one page. To call long distance or to call for other information, one would have to dial "0." Some of the listed businesses were: Bailey Hotel; Bank of Pompano; Banders Drug Co.; Clover Farm Stores; Fox's Pharmacy; Pompano Cash Supply Co.; Pompano Lumber Co.; Pompano Motor Sales Co.; Pompano *News*; and Postal Telegraph Co. Several of the public offices that were listed included the Board of Public Instruction; Pompano City Clerk; and Pompano Fire Department. To make a phone call, one would have to dial only four numbers. The installation of an automatic dial system was completed in 1931. Pompano in the 1920s extended to Northeast Thirteenth Avenue. Eastward the land was ideal for hunting, boating, fishing and picnicking before the plotting of subdivisions took place.

Boom and Bust

A Labor Day capacity crowd watches junk car races at the original Pompano racetrack on September 5, 1927. The Pompano Harness Track and Isle Casino are now located on this site at Powerline Road and Southwest Third Street. *Florida State Archives.*

As was common practice in municipalities in this period, community volunteers were the ones who responded to fires in Pompano. The chief, however, did receive pay. A siren mounted at the top of the city's water tank sounded the alarm announcing a fire. By dividing the city into four quadrants, there were one, two, three or four blasts that identified the location of where the fire was burning. Before a volunteer was accepted he had to pass a test.

In 1926 the city purchased its first firetruck for $13,000. The America La France Company of Elmira, New York, built it. The firetruck had a pumping capacity of 750 gallons per minute, but it could hold only one hundred gallons in its tank. Fire hydrants did not exist, and bucket brigades assisted to fight fires. The second firetruck was a 1948 America La France named Invader and was used until the 1970s. Both trucks have been restored by firefighters, who continue to maintain them in mint condition. The original fire station was built in 1926 and functioned until 1948 when the city converted it for storage. Restoration began in 1986, and it opened the following year as the Firehouse Museum located at 215 Northeast Fourth Avenue.

The Bank of Pompano, with Cecil H. Cates as its president, began business in 1923. It soon fell victim to the notorious Ashley Gang, led by young John Ashley, whose father lived in Pompano. The Ashley Gang specialized in bank robberies for more than a

The restored 1926 firetruck rests in front of the Old Pompano Fire Station, which now houses the Fire Museum at Founders Park. The city purchased a second America La France firetruck in 1948, which has also been restored. *Author Collection.*

Boom and Bust

decade in southeast Florida. One may compare them to the James and Dalton gangs. According to Gene M. Burnett in *Florida's Past* (1986), John Ashley was a "one-eyed sharp-shooter with the cunning of a swamp rat who led his motley members on a spree of bank robberies, shootouts, bold hijackings in the lucrative rum running trade, and sundry other forms of larceny and mayhem…"

In September 1924 the Ashley gang entered the Bank of Pompano, located at Northeast First Street and Northeast 1st Avenue, and forced cashiers Cecil H. Cates and T.H. Meyers to turn over $5,000 in cash and $18,000 in securities from the vault and $2,000 in cash from the teller's drawer, wrapped it all in a bedsheet and escaped in a stolen taxicab. Ashley waved the bundled sheet of money at onlookers as the vehicle turned off Flagler Avenue. The gang brazenly left a bullet with one of the bank employees to give to the sheriff. An informant gave information that the gang was in Fort Pierce, and the sheriff and his five deputies confronted them on November 1 in a shootout at the narrow, wooden Sebastian River Bridge. Bullets flew, resulting in the death of Ashley and his three associates in crime, Ray Lynn, Hanford Mobley and John Clarence Middleton. This was the end of the infamous Ashley Gang. The loot was never found.

World War I began in August 1914 and ended November 11, 1918; it had devastating effects on western civilization as empires collapsed and millions were killed or wounded. The United States remained neutral until April 1917 when it entered the war on the side of the Allies. On the local level the international conflict would touch the lives of Pompano residents, many of whom were called to the colors. According to the Florida State Archives' records, the following Pompano citizens entered the armed services: Henry Blaine, James D. Blount, William H. Blount, Jesse Britt, William H. Britt, Raymond S. Carter, Reene Cooper, Junious M. Fain, James G. Hardin, Thomas Harry, Ralph W. Hewell, Charles Hiers, Guy R. Howell, Henry L. Lyons, General Harrison Miller, Willie Irvin Miller, Robert A. Myrick, Cummin S. Reese, Lee M. Sample, Lonnie C. Skates, Liberty W. Slaughter, Daniel Jackson Smith, William E. Smith, Oliver B. Smoak, Nimrod James Walton, William A. Walton, James Gordon Weaver and Robert Williams. Of this group, Henry Blaine, Reene Cooper, Thomas Harry and Robert Williams were African Americans.

The post-World War I era, labeled the Roaring Twenties, witnessed phenomenal growth in Florida. On the Gulf Coast the railroad now traveled south beyond Naples; on the East Coast the railroad extended to Key West. Thirteen new counties were created between 1921 and 1925. New roads were constructed connecting the urban centers. The Tamiami Trail opened in 1928 going through the Everglades.

Pompano was affected by these events. Its population totaled 650 in 1924. Pompano land values skyrocketed, most of which was caused by speculation that resulted in overvalued properties. The Walton Hotel opened its doors in 1925 at Northeast First Avenue and First Street to accommodate the brokers and businesspeople involved in the economic expansion of Pompano. The hotel rose three stories and featured thirty-four rooms. It was conveniently located near the railroad station and was considered to be the most appealing structure in town. The hotel was sold in 1936 to R.T. Hodges and

Boom and Bust

C.J. Atwater for $25,000. Several months later John Walton was killed in an automobile crash. A prominent civic leader, Walton held positions on the Broward County Board of Commissioners, serving as its chairman on three occasions. Two years later Louise and Don Aurand bought the hotel and maintained its reputation as the most outstanding facility of its kind in the area. The Walton Hotel was the center of social and political activity where leading public figures put in appearances to campaign and be seen. As the economy shifted eastward, the hotel's elegance lost its appeal. The Aurands closed the dining room in the 1940s and sold the hotel to the First Baptist Church in 1950. Don Aurand commented, "The Walton was never the kind of hotel that succumbed to the tinsel on the beach and the big pond out there." However, its demise marked an end to an important cultural icon in local history.

High-powered advertisements helped to promote investment in real estate. As early as January 15, 1915, an advertisement in the Fort Lauderdale *Sentinel* announced that for the "Finest Citrus and Vegetable Land" visitors were welcomed to Pompano to purchase real estate at Cassels Hammock. The visitors were promised a "Free Auto Trip" and "Free Presents" to take advantage of "The Season's Opportunity in Land Values." A dinner was to be served by the Ladies of the Pompano Civic Association. Sales were to be conducted by "Dammers & Gillette, Famous New York Auctioneers."

Promotions for land sales continued to be exaggerated. The following section of an advertisement in the *Palm Beach Post*, July 25, 1925, further illustrates this point:

> *Thousand of times people have said: "If we had only come to Miami, Fort Lauderdale, or Palm Beach and purchased lots six or seven years ago." And now we say to you that Pompano Terrace lots of Pompano offer better investment opportunities than Miami, Palm Beach, or Fort Lauderdale did six or seven years ago. The East Coast of Florida between Palm Beach and Miami is generally conceded to be the Gold Coast of America. Most of the people who live and work in Florida indicate that they want to live on the coast. Therefore, the Southeast Coast of Florida—already established as the world's premier resort section—must become the business center of all of Southeastern Florida—and in a sense, the social center of America. There a great city, sixty to seventy miles and five to eight miles wide will be built—is now being built. Into that narrow strip of land…is being poured more of the world's wealth than ever was poured into any similar area before.*

The ad identified Pompano Terrace as being close to the ocean, west of Dixie Highway, at the FEC Railway, with all services available. "Big Profits Are Guaranteed" and "Millions Will Be Made," screamed the headlines. The listing price for each stucco home was $5,000. Considering the prosperous times and the prevailing mindset of the 1920s, this promotion seemed irresistible. In addition to Pompano Terrace, other real estate developments being planned and promoted were Avondale, Highlands, Lafayette, Pen-Mar, Pompano Villa, Sunnyland and West Avondale. Moe Katz, prominent community leader, further emphasized the importance of these events when he stated, "The real estate firm of J. Wellington Roe had a flock of salesmen and did a whale of a business.

People were buying like crazy." Journalist Mark Sullivan commented that there "was a torrent of migration pouring into Florida" in the decade of the twenties quite different in comparison from the nation's gold rushes, oil booms and free land stampedes.

David A. Ballou was one of the many people who were attracted to the boom in south Florida. He arrived in Pompano in 1924 from Elk City, Oklahoma, where he was born twelve years earlier. He attended Monteverde Vocational School and graduated from Pompano High School in 1930. He began a successful business career. The Pompano Lumber Company employed him. He joined with several colleagues to open the Broward-Palm Beach Tractor Company in 1949, becoming its president. He became active in community affairs as a leader in the Florida Farm Equipment Dealers Association and Pompano Lions Club, and was a member of the Pompano Beach Recreation Committee that was the catalyst for the construction of the eighteen-hole golf course, swimming pool, airport and tennis courts—facilities that helped to modernize the city. He was a director of the Margate National Bank and a member of the First Baptist Church and the Pompano Board of Trade.

But economic prosperity in the 1920s was not to last. Boom would lead to bust. Many real estate developments failed when prices crashed. One property on Federal Highway, valued at $40,000–$80,000 in 1925, dropped to $10,000 in 1928. Another lot dropped from $83,000 to $1,250. Presaging the economic collapse of 1929 were two severe hurricanes that damaged much of South Florida. The first occurred on September 18, 1926, when the three miles of dike failed at Lake Okeechobee and 373 people were killed (none in Pompano); 6,381 were injured (none in Pompano); and 17,884 families were affected (150 in Pompano). Judge Beckton Isler, assistant keeper of the Hillsboro Lighthouse, remained at his station atop the lighthouse continuously for thirty-two hours recording weather conditions (winds reached 132mph) and making sure that the light beams were functioning. David F. Butler, in his book *Hillsboro Lighthouse* (1997), quoted Isler's recollection of his storm experience:

> *The heavy winds and surging sea kept hammering away at the tower until I was certain it would topple into the Hillsboro Inlet. The vibration in the lighthouse was terrific, and the relentless wind blew off the roof of the boathouse, and the sea carried the small boat away.*

Despite the violent hurricanes and storms during its long history, the Hillsboro Lighthouse has remained a viable testament to its excellent structural integrity.

Another eyewitness to the 1926 hurricane, Virginia Shuman Young, vividly remembered, as a nine-year-old child in her home at Southeast 9th Street in Fort Lauderdale, water rising on top of the family's dining room table. At nearby Las Olas Boulevard she said "water was running down it in waves. There was slime and mud and fish, even in our house." Her father gave each of the four children a tablespoon of whiskey because they were cold and wet and scared and hungry. Pompano suffered from the violence of the storm. Trees were uprooted, homes destroyed, roads clogged with debris and animals and fish lay dead throughout the area.

Boom and Bust

Yet despite the death and destruction, the resilient spirit of the people was expressed in the many signs that appeared reading: "Down But Not Out," "Wiped Out But Still Smiling" and "No Increase in Prices. If You Are Destitute, It's Free."

The second hurricane on September 16, 1928, in South Florida produced fierce winds up to one hundred and thirty miles per hour and resulted in the loss of nearly two thousand lives. (A hurricane is a tropical storm that reaches winds of at least seventy-four miles per hour.) Governor Martin declared a state of emergency. Lake Okeechobee's banks overflowed causing death and destruction. President-elect Herbert Hoover visited the area to survey the damage. The recently constructed Pompano Theater was destroyed. The American Red Cross moved in to aid during the two hurricanes. The public library that had been established by the women's club was destroyed. Previously there had been a lending library open on Saturdays in the home of Margaret McDowell. Pompano resident Edgar Smoak remarked of the 1928 hurricane that the "storm packed drenching rains and such fierce winds it caused thousands of dollars of crop damage in Pompano." Nevertheless, the farmers continued to produce a bounty of vegetables, especially beans and peppers. In 1929 over 1,500 railroad carloads of vegetables were shipped out. The Bank of Pompano, which began business in 1923, failed as the Great Depression made its impact. The town was now without a bank to conduct business. Foreclosures on mortgages mounted. With the bursting of the land boom bubble, the entire Florida financial structure was affected. On the eve of the stock market crash in 1929, over eighty banks failed. Lorena Hardin Robson who was employed by the bank and the town said that during the Great Depression, "Only about thirteen percent of the taxes levied were collected."

These events caused a rippling effect throughout the economy. Pompano experienced financial hardship and had difficulty providing necessary services to the community. Mayor W.H. Shuford was forced to take a cut in salary, from $100 to $75 a month. Other city personnel also had their monthly salaries reduced: chief of police from $175 to $135; patrolmen from $150 to $125; fire chief from $200 to $125; and city clerk from $175 to $125. The local and national mood grew pessimistic. In this crucial period in the history of Pompano challenges arose, but they would be overcome while its people advanced into a new modern era.

At the beginning of the Great Depression the Christian Pallbearers Society was established by blacks in South Florida. The purpose was similar to the older mutual aid societies among immigrant groups: to provide insurance costs for members' burials. Pompano was the third town in Broward County to form such a group, after Fort Lauderdale and Dania. The Christian Pallbearers Society formed the Westview Cemetery located at Northwest Fifteenth Avenue between Powerline Road and Copans Road. Esther Rolle (1920–1998) is buried there.

It is important to flash back to the 2006 reprint of the *History of Broward County*, written by Frances H. Miner, and originally published in 1936 by the Works Projects Administration Florida Writers' Project of President Franklin D. Roosevelt's New Deal. Miner, employed by the WPA Florida Writers' Project, described the 1936 Pompano town in the following passage:

Pompano Beach

The powerful 1928 hurricane destroyed the Pompano Theater. The natural disaster contributed to the real estate decline and economic depression that followed. *Florida State Archives.*

Located at the northwest corner of Atlantic Boulevard and Federal Highway in 1937, the quaint Texaco gas station has been replaced by a more contemporary facility. *Betty and Dennis McNab.*

> [O]riginally a fishing village on the ocean but moved inland to its present site after suffering damage in the 1928 hurricane. An engineer [Franklin Sheene] surveying the area for the railroad in early days was so delighted with the flavor of a fish served him at dinner that, on learning it was called pompano and abounded in near-by waters, he wrote "Pompano" on the map as the community's name. The pompano, also known as butterfish for its fine-textured flesh and delicious flavor, is Florida's rarest and choicest food fish, and brings the highest market prices. It can be caught with hook and line, but nets were usually employed. Pompano papilotte, baked in a sealed paper bag with an aromatic dressing of herbs, is a dish to please the most fastidious epicure. Somewhat belying the town's name, truck farming is of first importance. When winter crops of beans and peppers are harvested, northern buyers arrive, and the town's loading platforms and warehouses, deserted for months, become centers of great activity.

Miner pointed out that Pompano was midway between Palm Beach and Miami, thirty-five miles either way, and on the Dixie Highway. The town boasted that its water did not need to be treated. She stated that the summer population was 3,200, while the winter population reached six thousand.

Multitalented entrepreneur William L. Kester helped to shape the development of Pompano through his investments in banking, land acquisition, tourism and philanthropy. He settled in Florida for health and recreational reasons. *Pompano Beach Historical Museum.*

continued to invest in the depressed economy and would be ready to benefit when the economy turned around. He recognized the importance of the railroads, cooperating with and promoting the Florida East Coast Railroad and the recently completed Seaboard Air Line Railway (1926), just west of the FEC. (Today the Seaboard is owned by the CSX Railroad, which was previously named the Chesapeake and Ohio Railroad.) He organized the Pompano Anglers Club to promote fishing as an important part of

recreational life. The plentiful supply of delicious fish was to be exploited for positive economic gain. Roland Hardy, who was president of the first insurance company in Pompano Beach, remarked, "Fishing was always good around Hillsboro Inlet. Once I saw a crew of a fishing boat net 100,000 pounds of mullet in less than a day." Captain John J. Whitmer was the first charter fisherman at the inlet, and a very successful one. Boating became an important related sport, helping to develop an industry linked to tourism. Kester gave out prizes to popularize fishing and boating.

He briefly got involved in politics and was elected to the city council in 1927, serving through 1928. He helped to expand and develop the infrastructure system of the city. Lighting, road construction, water and sewage facilities were advanced to meet the needs of a growing population and to enhance an expanding business climate. John O. Cook was the mayor of the city at this time. Kester continued to build private homes and business structures. For example, he built four six-room houses in 1931 costing $1,500 each. He saw a bright future for Pompano, and he wanted to play an instrumental role in that future. He vigorously applied his talents to promote his adopted city. Of course in doing so, he himself would benefit.

Kester had purchased such a huge amount of land, and later developed it, that he began to give away acreage for important community purposes. He built the Kester Building on Old Dixie Highway. He donated land of five acres for a park that was named for him. He gave land for the public library, a cemetery, the Garden Club, the Episcopal Church, an athletic field and the Baptist Church in Deerfield. In 1934 he, along with his brother, Richard Clay Kester, B.F. Bailey, S.C. Fox, H.L. Lyons and W.G. Miller, reopened the local bank as the Farmers Bank of Pompano and set up headquarters at the old Bank of Pompano building. He was the first bank president and held this position until his death in 1954. In this role he was able to become involved in the direction of the city's economic expansion. His brother, Richard Clay, followed as the bank's president, who in turn was followed by his nephew, Robert L. Kester. The bank's name was changed to the Pompano Beach Bank and Trust Company, and then to Florida Coast Bank of Pompano Beach. The historic bank building remains standing on Northeast First Street and First Avenue and is slowly being restored.

Kester sold much of his land at a profit. A section of land on the Intracoastal Waterway was sold in 1951 and it became a part of Lighthouse Point, which incorporated into a city in 1956. In 1952 he sold land that was developed into present-day Harbor Village. Just before his death he sold the land where the cove is now situated in Deerfield Beach.

Among his many contributions to Pompano Beach, William L. Kester is best known for the more than one hundred white-framed tourist cottages he constructed at or near the beach in 1937 on land that he had acquired earlier. Many were built at State Road A1A and lined both Atlantic Boulevard and Northeast First Street in Old Pompano. Popularly identified as the Kester Cottages or Kester's Ocean Colony, he boosted tourism through this venture even though the agricultural industry dominated the local economy at the time. He realized the importance of beach development for the community's recreational and economic potential. He himself lived on the ocean two blocks south of the Fourteenth Street Causeway at Twelfth Avenue. His vision of the future of the Gold

The Kester Cottages, built by William L. Kester in the 1930s at the Atlantic Ocean, created a tourist industry. The cottages were fully furnished and contained two or three bedrooms that were rented to honeymooners and tourists. *Pompano Beach Library.*

Coast was so significant that today over 90 percent of Florida's population lives less than one hour away from a beach.

It must be remembered that Kester's decision to build the cottages occurred during the critical period of the Great Depression. At first, people wondered who would live in them. The project created jobs and helped to generate economic growth. The small white-framed cottages were built of sturdy Dade County pine, which was termite proof and practically indestructible, at prices ranging from $900 to $1,500. Each cottage was built on concrete blocks anchored to the ground by steel. Wood paneling was used instead of plaster walls. The interiors were functional, lacking luxurious amenities. But they withstood the impact of hurricanes and other harsh conditions of an ocean-beach environment. Many young married couples first set up housekeeping in them at rents ranging from $10 to $25 per month. Tourists rented them for $25 per week. In the early 1960s, rents rose to $750 per month.

With a few exceptions most of the cottages have been demolished. By the 1970s about a dozen remained in the city, having yielded to the housing boom. Some were sold and carted off to such faraway places as Lake Okeechobee, the Carolina mountains and the Florida Keys. High-rise condominiums, businesses and other private structures have replaced the Kester Cottages. In 1974 Kester's nephew, Stewart, donated two of the cottages to the newly organized Pompano Beach Historical Society. As one of the oldest cities in South Florida, many business and civic leaders decided to preserve the early history during a

The Kester Era

pivotal time when the community was rapidly changing to a modern urban center. The cottages would be a place where memorabilia, documents, photographs and other records would be preserved. The Kester Cottages were themselves part of that heritage of the past, as well as the future home of the historical museum. The Pompano Beach Historical Society is located at 217 Northeast Fourth Street in Pompano Beach, at Founders Park. On May 4, 1954, the colorful life of William L. Kester ended with his death.

Ennis Warren Ballou (1910–1975) was instrumental in organizing the historical society in 1973–1974 with the assistance of county leaders Melville Sue Phillips, Cooper Kirk and Kenneth Walker. Local individuals who contributed their time and effort were librarian Frank Trenery, Ruby Sarvis, Gertrude Hopper, Ovieda Johnson, Freda Smith, Martha James, Florence Booth, Marjory Springmeyer, Gladys Walker, Loren Hardin Robson, Elizabeth Banks, Emma Lou Olson and Beverly and Lowery Davis. Ennis Warren Ballou was elected the first president of the historical society. Born in Pompano when the town was officially two years old, her father John L. Warren, a businessman, managed farm supplies. Her husband was David Ballou who owned the local John Deere Tractor Company. In the fall of 1974 the society's first antique show was a success; Henrietta McClellan guided the program as chairperson.

Wholesome events in the Kester Era contributed to community social activity that distracted citizens from their economic and financial pressures. For a unique form of entertainment, impresario Charles Collier produced such shows as *Silas Green from New Orleans* and *Orange Blossom*, and brought them to Pompano and other nearby towns in the period between the two world wars. Broadsides were posted on store windows, telephone poles and other public places advertising the event. *Silas Green from New Orleans* was a popular all-black show that featured dancing, comedy, prizes and music. Sometimes the event was preceded by a parade. The show lasted nearly two hours. The audience contained both blacks and whites, but they were separated in different sections. Pompano did not escape the racial segregation that the nation practiced. Local historian Edward L. (Bud) Garner recalled that the *Silas Green* shows were performed in a field east of Flagler and south of Northeast Fourth Street. Garner and other boys helped prepare the "stage" by spreading sawdust and wood shavings on the ground under a tent. The shows were moved to a vacant lot where city hall is located today. With little contemporary entertainment available the townspeople eagerly anticipated the minstrel shows. Lorena Hardin Robson remembered a "showboat used to come up the Pompano Canal and anchor and the entertainers would march uptown to the theater, south of where Ward's City [department store] is today."

There was a theater in the black section of town called the Loveland, which featured black movies, Hollywood films and live entertainment. In addition to fishing and boating, an enhancement to the total entertainment business was the Pompano Bathing and Dance Casino that was built in the 1920s and later acquired in 1940 by the city. The casino provided facilities for showers, dressing rooms, dining and dancing. It was located immediately south of Atlantic Boulevard at Briny Avenue at the ocean. Even though it was named a casino, no gambling was permitted. The Elks Club rented the building in 1953. The following year it was destroyed by fire.

Pompano's farming economy was enhanced in 1939 by the construction of the State Farmers Market, the largest in the United States. As a result, business activity shifted away from the railroad station at Flagler Avenue. *Florida State Archives.*

At the state level today, tourism is Florida's main economic resource, while agriculture is listed as the next resource in terms of importance. Florida is often among the top ten producers of agricultural products. The history of Pompano Beach has reflected at the local level what the roles of agriculture and tourism have played statewide.

As the initial stages of a tourist industry emerged in the early part of the twentieth century, Pompano was still primarily an agricultural community known for producing rich harvests of vegetables. The establishment of the Pompano State Farmers Market in November 1939, west of Dixie Highway and north of Atlantic Boulevard, became a major distribution center for these products and increased economic growth. It measured ninety-five feet wide and 1,008 feet long. The cost came to $150,000. "It was the fastest WPA project ever completed," observed Harvey S. Cheshire, who served nine years as a director on the Pompano State Farmers Board. An estimated crowd of nearly five thousand, many of whom were civic and business leaders, attended the market's dedication on land the Blount brothers had donated. Some opposition arose from merchants and individuals who felt that the new state farmers market would hurt the businesses that were established at the FEC Railroad station along Flagler Avenue. Yet change was inevitable as it was conceded that the old business center had become inadequate and antiquated. The new facility would serve what was considered to be the

The Kester Era

world's largest producer of winter vegetables. In future years, agricultural production would decline while distribution and processing would increase. The rise in land values and taxes accelerated this shift. Today the farmers market remains a valuable economic asset, but it handles agricultural products from many miles away and from farms that use advanced technical and mechanical methods.

Nevertheless, agriculture remained the basic economic resource in still rural Pompano. Henry Bud Lyons, for whom Lyons Road is named, owned huge amounts of farmland that extended west to what is today the City of Coral Springs. Lyons and B.F. Bailey, proprietors of the Broward County Truck Farms Corporation, purchased 6,200 acres of land west of Pompano. Actually, Lyons had been accumulating land since 1911 and owned over twenty thousand acres by the time World War II began. The land was wet and marshy and had to be cleared and drained for farming. Migrant farmers from the Bahamas contributed much of the manual labor for this task.

Author Clarence Woodbury labeled Lyons "Titan of the Bean Patch" in an article that appeared in *The Country Home Magazine* (January 1939) to show the important role he played in farming and processing his harvest of beans. Woodbury carefully described in detail how Lyons's fresh supply of beans was processed in his packinghouse at the Florida East Coast Railroad depot during the 1930s:

> *Scarcely less impressive than Bud Lyons's mammoth farm is his packing plant in Pompano where his beans are cleaned, graded, packed and loaded onto refrigerator cars the same day they are picked. Here electric conveyor belts first carry the beans under a powerful blower which removes any dust or soil from them, then on between rows of quick-fingered women, who throw out any broken, bruised or blighted beans, and sort them into two qualities at the end of each belt. The graded beans are dumped into bushel hampers. Men nail on lids, paste on labels, and place the hampers on an electric conveyor which takes them to waiting refrigerator cars or trucks. This season Bud Lyons expects to ship 500 and 600 carloads of beans northward, each containing 600 bushels. In addition he will ship thousands of bushels by truck, and others by boat from Port Everglades.*

As suburban development moved westward from the older towns near the ocean, the Coral Ridge Properties Company secured nearly four thousand acres of land from Lena Lyons in 1961 for one million dollars. Two years later Coral Springs became an incorporated city.

The original Pompano Chamber of Commerce was organized with one hundred and twenty-eight members in 1925. William L. Kester graciously allowed the chamber to be housed free in the Dixie Building on Old Dixie Highway. The economic future of Pompano was heralded in its publication, citing the improved infrastructure that would enhance business. The officers were John Walton, president; R.L. Merwin, vice-president; H.H. Sours, vice-president; H. Massell, treasurer; and E.P. Scott, secretary. Serving on the board of directors were L.S. Warren, J.M. Moore, I.B. Hilson, V.T. Mavity, William H. Blount, F.M. Carson and W.H. Shuford. Opposition to the chamber soon mounted from the local farmers who believed that the chamber, through its

By 1958 the Florida East Coast Railroad station could not hide its decay at the corner of North Dixie Highway and Hammondville (Third Street) in Old Pompano. *Pompano Beach Library.*

advertising, would bring in more farmers to the area and thus depress the agricultural market. The chamber failed after operating for more than a year.

The new chamber of commerce came into being in 1948 and was dedicated the following year. This organization has business and professional leaders who have promoted economic development through advertising and public relations. Robert Pool was the first president. Claude T. DeGraw served as the first secretary. Mrs. W.H. McNab donated the land on which the chamber operated at 2200 East Atlantic Boulevard. The chamber has extended its reach beyond the borders of Pompano Beach. Since other cities have similar organizations, the competition to secure new businesses is intense.

Now known as the Greater Pompano Beach Chamber of Commerce, with more than seven hundred members, it adopted at the outset the following goals in its operations: to promote agriculture, tourism, industry, civic activities, recreation and transportation. The chamber worked to get a recreational center (1953) that contained a municipal golf course, swimming pool, tennis courts, playground and community college; and supported the construction of the Pompano Park Harness Track (1964), as well as bringing in new businesses. The chamber's special events division sponsors and coordinates the annual Seaford Festival on the beach at the end of April, the fall golf tournament and the

The Kester Era

The Annual Pompano Beach Christmas Holiday Boat Parade is held every December on the Intracoastal Waterway. It started in 1962, and is the oldest boat parade in the nation. *Pompano Beach Chamber of Commerce.*

The talented Pompano Beach Little League Team became the 1948 East Coast Champions. Carl Shuster is standing second from the left, with his proud teammates. *Florida State Archives.*

Pompano Beach

A North Federal Highway scene projects an image of a quaint country road in 1959. The Pompano Beach Chamber of Commerce participated in landscaping the median. *Pompano Beach Library.*

annual Christmas Holiday Boat Parade in December, the oldest continuous boat parade in the nation.

The Chris Craft Corporation chose Pompano Beach as its world headquarters in 1957, eventually locating its factory and sales office on Federal Highway. It counted nearly six hundred employees. Soon other small- to medium-sized electronics and manufacturing companies set up shop in the area. In 1958 the Kett Technical Center came to Pompano Beach, a subsidiary of United States Industries offering technical advice in various engineering services. The city's population in 1940 was 4,427; in 1950 it was 5,682; and ten years later it had reached 15,992. A total of 1,166 students attended Pompano schools during 1945–1946. In 1955–1956 school attendance rose to 4,435. This remarkable overall increase in population proved that the city was becoming a desirable place to live and work.

Brumby Oneal "Bo" Giddens was a contemporary of Kester, coming to Pompano from Georgia at the same time in 1925, and also played an important role in the town's

growth. He immediately became involved in civic affairs as councilman in 1925, as mayor in 1936 and again as councilman in 1946. After his first stint in government he was hired as the city's fire chief, water superintendent and building and electrical inspector at a salary of $50 a month. He married Mattie Ogden in 1928 and they set up housekeeping in the new firehouse until 1934 when they moved to the Monticello Park. The Giddenses owned a restaurant in the Beville Building (still standing) at North Flagler Avenue and Bo's Lunch restaurant on Hammondville Road. Bo and Mattie built a Dade County pine house at 305 Northeast Third Street and Northeast Third Avenue in 1939 with the first FHA loan in Pompano. The land cost $50 and the construction cost was $3,000 at a time when the economy was depressed.

When World War II started, Bo Giddens went to work in a defense plant in Cleveland, Ohio, while his wife Mattie remained in Pompano to manage the Bailey Hotel and to care for their three children. When the war ended he returned to Pompano and worked to acquire the airport property, to form the new City of Pompano Beach in 1947 and to advance the community infrastructure with the construction of the first water tower and by hiring the first caretaker for the cemetery. In the last twenty years of his life he began to buy land and engage in farming. He died in 1968. The Bo Giddens House, representing the frame vernacular style of architecture, is showcased on the Old Pompano historic homes tour.

As the economy expanded and the nation emerged from World War II, prices appeared to be stabilizing. In 1949 Pompano residents could enjoy a complete Thanksgiving dinner for $2.00, including dessert and coffee; a children's plate cost $0.95. This special dinner could be had at Sonja's Dining Room located at 8 Northeast Second Street. Sonja's specialized in "Swedish Home Cooking." On December 1, 1950, the Pompano Beach *Town News* contained an advertisement paid for by the O.L. Guest Furniture and Appliances store, located at 124 North Flagler Avenue. The ad offered an Apex fully automatic electric dishwasher for "only $169.50, complete." The listed store phone number contained three digits: 515. The *Town News* also announced the plans for the proposed library on land donated by William L. Kester.

5.
The World War II Era

By the 1940s the original town of Pompano had begun to establish a new identity. The community center at the FEC railroad station area experienced an evolving shift eastward, past Federal Highway to the beach and its environs. New shopping centers, tourism and light industry would produce a modern era. The once glory days of agriculture were disappearing because of increased land values and a need for housing in a new commercially-geared society. The old commercial center gradually decayed to the extent that in recent years there has been an almost constant attempt to revive it. Ethnic and racial groups, especially in civil rights, made advances. Higher education was emphasized. Increased prosperity led to the rise of the suburbs, dominance of an automobile culture and a decline of the old urban centers. The nation was on the verge of a revolution in the space and nuclear industries, in technology, communications, transportation and electronics, all having been accelerated by World War II, which is the great watershed in twentieth-century America. Millions of troops returned home to contribute to and be a part of these events. In fact, many who had served in South Florida during the war returned to settle there. Those fortunate to come home unscathed were more sophisticated and had higher expectations. The GI Bill of Rights opened new educational opportunities for them. Old Pompano would be caught up in these changes.

These World War II developments affected Pompano directly. Much of South Florida and the nation geared up for total war. The U.S. government purchased land in Pompano to build an airfield to train pilots. The land was bought from J.H. Chapman for $53 an acre. The Pompano Air Base trained pilots as a part of the Fort Lauderdale Naval Air Station. Following the war the airfield was deeded to the city under the 1944 Surplus Property Act. Part of the land was slated for recreational facilities. The creation of the municipal airport represented one of the prize assets of the city. It was dedicated in December 1949 in memory of Sterling McClellan Jr., a bomber pilot who was killed during World War II. An air show helped to celebrate the occasion. Virginia Congressman Clifton A. Woodrum and Commander Robert Wallace of the Florida Veterans of Foreign Wars gave speeches.

The municipal airport, also known as the air park, serves as the base for the Goodyear blimp, the first being the *Enterprise*. The 1979 arrival of the first blimp, which had been

An aerial view from Northeast Tenth Street and Federal Highway (foreground looking west) shows the landing strip of the municipal air park in 1968. *Pompano Beach Library.*

based in Miami's Watson Island, was inaugurated with parades and other ceremonies. Mayor Emma Olson christened the *Enterprise* while Goodyear Board Chairman Charles J. Pilliod looked on. The Pompano Fire Department used its heavy equipment to lift both Olson and Pilliod thirty-five feet into the air to the nose of the airship. Mayor Olson observed, "Goodyear blimps have become an American tradition and we are delighted to have the *Enterprise* based here in the heart of the Gold Coast." Mayor Olson became a part of the elite group of women who christened Goodyear airships. Amelia

The World War II Era

The impressive sight of the first Goodyear airship, *Enterprise*, soars overhead during its arrival at the Pompano air park in 1979. The new blimp, the *Spirit of Innovation*, was based there in 2006. *Pompano Beach Library.*

Earhart performed the honors for the blimp *Defender* in 1929, and the first lady Mrs. Herbert Hoover christened the navy airship USS *Akron* in 1931.

In July 2006 a crowd of more than three thousand gathered at the air park to greet the new Goodyear blimp, the *Spirit of Innovation*. It is the first Goodyear blimp to be named by the public through a worldwide, web-based "name the blimp" contest. The *Spirit of Innovation* is 192 feet long, 59.5 feet tall and 50 feet wide. It is a familiar sight in the skies over Pompano Beach. Its chief pilot is Larry Chambers, assisted by pilots Marty Chandler, Brian Comer and Matthew St. John.

Construction of an administration building and a hangar began immediately on the new base in 1979. Pompano Beach was the only city in the world where public flights on a Goodyear airship could be purchased. Flights on the *Enterprise* cost $7.50 for an adult and $5.00 for a child under twelve years old. Only six passengers could be taken on a single flight. In 1979 Goodyear had three other airships: the *America*, based in Houston; the *Columbia*, based in Los Angeles; and the *Europa*, based in Rome, Italy. The new Goodyear blimp, the *Spirit of Innovation*, is often seen in the sky over the city and flying along the Atlantic Ocean coastline. It has brought considerable notoriety to Pompano Beach.

During World War II hostile German submarines patrolled the coast of Florida, often wreaking death and destruction. The German submarine, *U-128*, sank the *Pan Massachusetts*, a tanker, off southeast Cape Canaveral on February 19, 1942. Two days later two more tankers were torpedoed, this time by the German sister sub *U-504*. The next day, off Palm Beach, another tanker, *W.D. Anderson*, was sunk. Antisubmarine defenses were woefully weak, attempting to protect the extensive Florida coast. In May 1942 there were eighty-six vessels sunk at or near the Gulf area and the Atlantic Ocean. Debris from sunken ships could be found strewn on the beaches. By the middle of 1943, American sea defenses had finally turned the tide with better equipment and an effective strategy. The Hillsboro Lighthouse remained dark during the war.

Pompano is proud of its veterans. Oscar K. Johnson contributed to the war effort, serving his country in the Army Air Corps from 1943 to 1945. He was a gunner on a B-17 bomber. He became a prisoner of war for nearly six months in Germany. Born to Callie Edna Umstead and Oscar Kelly Johnson, he was a native-born Pompano citizen. Johnson attended Pompano Elementary School and Pompano High School, and the University of Florida from 1946 to 1948. From 1946 to 1969 he engaged in farming and after 1969 he was in the real estate business. He holds the 32nd degree Scottish rite in the Masons. He is a member of the Christ Church of the United Methodist congregation.

His brother, Florida native Edward Carleton Johnson, who was born in 1927 in Live Oak, entered World War II in its last year and served his country in San Diego and Japan from 1945–1946, a time when General Douglas MacArthur led an American victory in the Pacific theater and transformed Japan into a democratic nation. He settled with his family in Pompano, attended Pompano High School, worked for the Florida Agricultural Supply Company (1950–1954) and for the Pompano Produce Market until 1956. Soon after, he became a real estate broker. Edward Carleton Johnson is also a member of the Methodist Church, Sigma Nu Fraternity, and received the 32nd degree Scottish rite in the Masons.

On the Pompano home front volunteers patrolled the oceanfront to protect against submarine attacks. German submarines were reported within a mile of the coast. Blackouts took hold. Volunteers patrolled the coast looking for subs and enemy infiltrators. The *Pompano Planter* issue of September 18, 1942, announced, "The Coast Guard Horse Patrol, Pompano Unit, has swung into regular action. A full complement of horses is stabled at the beach." Lookout structures were manned. The United States Coast Guard established a control facility at the Silver Thatch Hotel and Racquet Club and a base at the Hillsboro Lighthouse. Rationing and saving essential materials contributed to the war effort. In the same issue, the *Pompano Planter* reported that the Pompano Lions Club collected over seventeen tons of scrap for the war effort and placed the material on the FEC platform for purchase by a junk buyer. Proceeds from the sale went to the community welfare fund. Throughout the home front, locally and nationally, Americans sacrificed as much as possible to help those on the battlefield.

There was a U.S. Naval submarine named *Pompano* that did service during World War II. The USS *Pompano* was a P class sub commissioned March 11, 1937, just before the war began. It arrived at Pearl Harbor several days after the December 7, 1941, attack

there. After completing several successful missions in the Pacific, the USS *Pompano* set out on its seventh mission from Pearl Harbor in August 1943, venturing into the dangerous waters of the Japanese islands. It was never heard from again, an apparent casualty of sea combat. Seventy-six men were lost. Captain Lewis Smith Parks was the USS *Pompano's* first captain who was later transferred to another ship before 1943. After his retirement from the service as an admiral he settled down in Pompano Beach until his death. Edward L. (Bud) Garner, the local historical society's historian, composed a patriotic memorial for the occasion that read, "We, the people of the city of pompano (fish) Pompano (city) *Pompano* (ship) the most caring, compassionate, benevolent, and pleasant place in which to live. We owe this to these men." The flag that flew on the USS *Pompano* now rests in the archives of the Pompano Beach Historical Society, as well as the silver container that held the christening bottle. Also, a special commemorative stamp was issued August 8, 1987, honoring the submarine.

Edward L. (Bud) Garner's residency has spanned a long period of local history. He was only nine months old when his family moved from Alabama to Pompano. His father was a section foreman on the Florida East Coast Railroad who was promoted to area supervisor and completed forty-five years with the railroad. Garner graduated from the Pompano public schools. In 1943 he joined the navy and served three years in the Atlantic and Pacific zones. Garner's wartime service covered many thousands of miles. He and his wife Doris have four children, six grandchildren and three great-grandchildren. Four generations of the Garner family have attended Pompano schools.

He remembered Pompano school days in the 1930s and 1940s. He entered first grade in a large yellow two-story stucco building on Northeast Sixth Street. Garner's elementary school teachers were Miss Hattie Banks, Miss McQueen, Miss Gladdin and Miss Kelly. At first, female teachers were not allowed to marry. In high school he had a different teacher for each subject. Mr. Carmichael taught math and algebra, and he was also the football and basketball coach. The truant officer was Mr. Baer who had to deal with all of Broward County; he therefore spent little time in Pompano. Garner reminisced further in his book, *Tales of Old Pompano* (1998):

> *Once reaching high school there was a different sense of belonging. We could take part in different activities, such as "field day," which was usually on a Friday toward the end of the school year in April or May. This was our intramural sports competition, with an emphasis between grades rather than individuals. We had 50-yd, 100-yd, 900-relay races, bicycle races, standing broad jump, running broad jump, pole vault, football toss, basketball shoot, rope climb, shot-put, javelin throw, discus throw and enough secondary activities to keep everyone involved for the entire day.*

Garner has dedicated himself to preserving the history of his beloved city. He has written and published numerous works on the subject so that future generations will have access to that past. As an active member of the Pompano Beach Historical Society, the Broward County Historical Commission honored him and wife Doris as pioneers in 1997.

POMPANO BEACH

An agricultural worker harvests snap beans on a local farm during the 1950s. The term "Beanpickers" became an identifying symbol for the large number of farmworkers. *Florida State Archives.*

Garner has sought to keep alive the memories of the "Beanpickers." The term derived from those individuals who harvested beans during the prosperous agricultural period. Thus, beanpicker meant farmworker. New towns have sprung up where beans, peppers, eggplants and tomatoes once grew in Broward County. The name also was associated with Pompano High School from 1928 to 1957. Following this period, beanpicker became irrelevant and outdated and the high school has since been known as the Golden Tornados, although the blue and yellow colors remained.

Though the Beanpicker era ended in 1957, the high school graduates continue to hold reunions. Garner (class of 1948) was among 250 original Beanpickers that met on the last weekend of May 2005 at the Pompano Beach Elks Club to renew old memories. During the Beanpicker era the numbers read as follows: 1,073 were original graduates; 391 had died; 567 were still living; and 115 had not been located.

Myrtle Darsey (1910–2003) was the 1928 valedictorian of Pompano High School's first graduating class, Marion Walton the salutatorian. A total of eight students comprised this first class. In 1952 Claire Canfield (class of 1952) composed the following school song:

> *For we are students of old Pompano High*
> *To show our love for her will never die*
> *For we are fighting for old PHS*

The World War II Era

Pompano Beach High School assumed the name Beanpickers from 1928 to 1957, afterward taking the name Golden Tornados. Old-timers keep the Beanpickers era alive through reunions. *Pompano Beach Historical Museum.*

> *We count on every one of you to do your best*
> *For we will fight, fight, fight whenever we can*
> *For she's the best old school in all the land*
> *For POMPANO HIGH SCHOOLS rep we'll*
> *Never fear*
> *So give a cheer.*
> *Rah! Rah! Rah!*

Francine G. Anderson of the northwest section of Pompano remembered starting her formal education at the "colored" school when she was eight years old in 1935. Mrs. Blanche Ely was the principal. School actually started in June and continued through the summer and through the fall. The school calendar was determined by the growing season, usually to December. The children worked on the farms until the season was over. Then school began again in June. Anderson later attended the Blanche Ely Adult School and studied for one year at Broward Community College.

Anderson was born in West Palm Beach in 1927. She was one of eleven children. Like many others at the time, she migrated south with her family to find work picking beans and other vegetables. Pompano's segregated community had one street that ran from Firebridge (now Eighth Avenue) down to the FEC Railway train station. The highway that ran north and south was Old Dixie. Her mother and Miss Cason, who

Pompano Beach

Smiling students represent the 1955 graduating class of Pompano Beach High School. Their teacher is on the right. Dennis McNab is standing on the left. *Betty and Dennis McNab.*

was a midwife, worked in the home of Midi Lyons as maid and laundry aide. The pay was $0.75 a day.

Anderson recalled the jailhouse being built down a rock road off what is now Third Avenue. A white dentist would visit the area, provide dental care and charge a "small sum." Most of her neighbors lived in quarters owned by the white farm owners. They shopped at Fred Mule's Store and Marbley's Dress Shop. She and her second husband, Joseph W. Anderson, produced four children. She was employed as a bookkeeper at the Coleman Elementary School, a cafeteria cook at Ely High School, a food service supervisor at the Pompano Beach Hospital and as a cosmetologist.

Alfred Ernest Thurston has seen profound changes during his seventy-seven years in Pompano Beach. He overcame many obstacles in his quest to achieve success. Born in 1930, his father built the family house in the local community known as Newtown. He graduated from the Pompano Colored School in 1948 and later graduated from Dilliard High School. Before transportation was provided for black students, Thurston devised various means to reach Dilliard High School in Fort Lauderdale: public transportation, Greyhound bus and even hitchhiking. His commitment to hard work earned him

The World War II Era

leadership roles as a teenager. He became president of the NAACP Youth Chapter, was a Boy Scout and rose to the rank of Star Scout and became a scoutmaster.

The limited opportunities for Thurston increased in the post-World War II period. To earn money for college he worked briefly as a sharecropper. He enrolled at, and worked his way through, AET College in Greensboro, North Carolina, in the late 1950s. His educational career brought him back to Pompano Beach as a science teacher. He eventually became chairman of the science department at Ely High School and the Parkway School. He retired in 1992. Alfred Ernest Thurston and his wife Juanita brought five children into the world. He was actively involved in Mount Calvary Baptist Church for more than four decades as a deacon, teacher, financial minister and treasurer.

Another contemporary unsung educational leader was Carolyn P. Payne who was born in Georgia in 1918. After attending school in Milledgeville, she graduated from Georgia State College for Women and Vanderbilt University. She arrived in Pompano Beach in 1947 as librarian at Pompano Beach Senior High School, serving from 1947 to 1976. Since railroad trains were popular modes of transportation, she remembered arriving on the Silver Meteor with Ernestine Davis and Mary Murphy who were also educators. Her first residence was at Mrs. Weatherby's on First Street across from the First Baptist Church where she was a member. Upon retiring she became active in the Broward County Retired Educators Association and moved to the John Knox Village.

With the exception of World War II, the most significant event to occur in this period was the merger of the eastern and western parts of Pompano. The Old Pompano western area, around the Florida East Coast Railroad station, was incorporated July 3, 1908, after thirty-one citizens had met at the railway station and agreed to become a new municipality. The town's founding fathers designated John R. Mizell mayor and police judge. Mizell had been a customs collector in Pensacola. J.K. Peacock was elected council president. Peacock was the owner of a general store at Northeast First Street and Flagler Avenue. George L. Blount Jr. was the first clerk of the new town and it was his responsibility to provide an official record of the incorporation proceedings for the Dade County Courthouse in Miami in 1908, which he did in July. This was necessary because Pompano was then a part of Dade, since Broward County did not exist. The rest of the leaders who comprised the original council consisted of E. Rogers, J.K. Howell, D. Smith and A.W. Turner. The following year Palm Beach County was cut off from Dade County.

Ora L. Jones, born in North Carolina, was not an original settler, but he was a keen observer of town life. A journalist by trade, he arrived in Pompano Beach after the 1935 hurricane destroyed the FEC Overseas Railroad. It became necessary to move his newspaper and printing press from Key West to Pompano the following year. He wrote the *Souvenir Historical Journal, 1908–1958* that covered the first fifty years of settlement. He often reported on the proceedings of city government, which he stated was "run" by the mayor and four councilmen. They received one dollar for each meeting, not to exceed five meetings in a month. The council proceedings were not guided by *Robert's Rules of Order* or any other rules for deliberative bodies, according to Jones. He described how the meetings were conducted:

"I ran into Harry McNab the other day," one councilman would say. "He thinks we ought to do something about that big mud hole near his home on Atlantic Boulevard." There would follow a prolonged informal discussion of some of farming, such as the merits of a certain kind of fertilizer or seeds, a report of a member's trip to Hot Springs and the benefits received from the hot baths there, maybe the relation of a funny story or two—in fact, anything and everything was discussed at considerable length except the matter of filling in a mud hole. When all the extraneous subjects had been discussed at length someone would inquire: "What are we going to do about that mud hole?" "I'll see Joe Smoak within the next few days and ask him to dump a wagon load of gravel in the hole," another would reply. "That would make Harry happy again."

Jones said their decisions were always sound, "never tainted by politics." Issues were settled with informalities and good fellowship abounding. The city office was located on the ground floor of the northwest corner of the Masonic Building. City Clerk Lorena H. Robson kept all the city's records and collected taxes and water rents. Lacking an assistant to help, she nevertheless was efficient; she even managed the bank account and paid all bills authorized by the council. Jones, who died July 10, 1971, at the age of eighty-four, pointed out with his folksy wisdom that John Dorsey and one night watchman constituted the police force in the late 1930s; the two officers frequently carried out their duties when the old Ford Model T broke down.

Two years after incorporation the town's population was recorded at 269. Despite the increased prosperity resulting from the production and sale of vegetables, Pompano's population had grown to only 4,427 by 1940. Tourism did bring more people into the area during the winter period, especially to the Kester Cottages and hotels, but permanent residents were slow to settle. The advance and application of air conditioning would change the face of South Florida from the 1950s onward.

Nevertheless, in the later 1930s and early 1940s, with growth trending eastward, a new community at the beach appeared that was quite different from Old Pompano. At the same time the older city made overtures to include the beach area in its border for more future revenue and to boost its image and power. Developers and property owners at the beach feared increased taxes and that Old Pompano controls would hamper their potential prosperity. They protested. Howard C. Jelks, owner of the Wahoo Beach Fishing Lodge and spokesman for the group, argued that his business had been declining and if the town of Pompano extended its reach it would mean additional expenses. Other businesses would be negatively affected.

These events provided the impetus for the eastern leadership to proceed to form its own government. The Pompano Beach Improvement Association organized meetings of the oceanfront community. The result was the incorporation of Pompano Beach in 1945 as a separate municipality. Charles Dickson, a Syracuse, New York banker was elected mayor. The elected council members were Richard Rodgers, Mary Beale, Phyllis Uibel and James B. Wilson Jr. Mrs. Hugh D. Stillman was appointed town clerk, and C.E. Jones became town marshal. William L. Kester, M.A. Hortt, Hugh D. Stillman, A.W. Schmidge, S.E. Northway, W.H. Johnson, J. Newton Hall and Andrew

The World War II Era

Brennan were selected to serve on the committee to draft a zoning code for the new municipality at the beach.

The two cities existing side by side was not to last long. A commission voted four to one to consolidate the old City of Pompano with new Pompano Beach, and the state government agreed. The merger set the name as Pompano Beach on June 16, 1947, and that name would be retained up to the present. Certain promises had been made to get the east to agree to this action, such as providing sanitation facilities on the beach. The merger also included an area that had been known as "no-man's-land" between the two towns; "no-man's-land" was a strip of land between Northeast Thirteenth Avenue and the Intracoastal Waterway. The transitional 1947 government consisted of Mayor Clyde Bland and Commissioners G.A. Allison, Albert Smoak, A. Brennan and Mr. LeFevre. The transition continued into 1948 that included Mayor H.T. Buck and Commissioners A. Brennan, G.T. Hull, Albert Smoak and Marion Walton. The mayor was selected by majority vote of the commissioners. Before 1947 the elected officials were known as "councilmen"; after that year they took the title "commissioners." H.P. Edmonds became city manager under the new government in 1948 and held that office for five years.

Though the merger of the two municipalities was effectively executed, there was an undercurrent of opposition that had surfaced. Hugh D. Stillman, a prominent realtor-developer and civic leader said, "The biggest mistake ever made was the merging of 'old' and 'new' Pompano Beach in 1947." Stillman had visualized a new community modeled on that of Hillsboro Beach with exclusive residences and hotels. Born in Jacksonville, he had moved to Miami, then to Fort Lauderdale and finally to Pompano. He joined the army in 1942 and served until 1945. He remembered what Pompano was like when he moved there in 1937: "There were wildcats, alligators, snakes and a million mosquitoes. It was the only place I've seen where sand flies traveled in droves. They looked like big black clouds." There were no telephones on the beach until after World War II. He was selling lots at Hillsboro Pines for $990 in 1957. In spite of Stillman's reservations about the merger, he took leadership positions in civic affairs that led to the formation of Holy Cross Hospital and the North Broward Hospital District. He served on various community boards. He was active in Rotary and St. Martin-In-The-Fields Episcopal Church.

The present Pompano Beach City Charter provides for a city commission–city manager form of government. There are five districts and each elected commissioner must reside in his/her district. The term is for two years. These districts must be reapportioned every ten years based on changes in the decennial population counts. In 2007 the city commission consisted of Kay McGinn (District 1), Charlotte Burrie (District 2), Rex Hardin (District 3), Pat Larkins (District 4 and vice mayor) and George Brummer (District 5).

A mayor presides over the commission. Since 2004 voters have elected the mayor on a citywide at-large basis for a three-year term. John C. Rayson became the first at-large elected mayor in that year. Lamar Fisher, former commissioner from District 3 and fourth generation resident, succeeded Rayson as mayor in 2007, running unopposed. The vice mayor is elected by the city commission at the first meeting after the annual

Jack Swain (1880–1947), community leader and member of Masonic Lodge 409, was a deacon at the Mount Cavalry Baptist Church. His descendants held a family reunion in 1983 at the church. *Eunice Cason Harvey.*

election. Pat Larkins (District 4) was elected to that position. The mayor does not have administrative duties.

The mayor and five commissioners enact all local legislation, adopt budgets, determine policies and appoint a city manager who carries out the laws and acts as chief administrator of the city. Except for purposes of inquiry, the city commission shall deal with the administrative services only through the city manager. C. William Hargett Jr. served in that capacity from 1995 to July 23, 2007, during a period when new growth and annexations added additional valuation to the city's tax base. The added valuation resulted in lower ad valorem taxes to all areas of the city. During his tenure the ad valorem tax rate dropped for thirteen years, and the homestead property value increased from $122,000,000 to nearly $760,000,000. The city commission appointed Garland Keith Chadwell to replace Hargett as city manager. Chadwell had twenty-four years experience in local government. He last served as deputy manager in Fulton County.

Other events helped to reshape the city in this period. The Sands Yachtel and Motel was opened in 1947 on Riverside Drive, north of Atlantic Boulevard, on the Intracoastal Waterway. The word "yachtel" was first used here. This project extended facilities for yachts, their crews and others. The widening of Atlantic Boulevard into four lanes for one and a half miles began in late 1961. It was hoped that the further widening and upgrading of the east–west road would revitalize Old Pompano. The last passenger train

The World War II Era

The old training track for harness racing, built in the 1950s (*upper left*) no longer exists. Atlantic Boulevard (*above*) runs east and west, as does Southwest Third Street (*center*). Pompano Park and Isle Casino now fill the open spaces. *Pompano Park Harness Track.*

to travel through Pompano Beach occurred in 1968 at a time when the automobile was dominating the American landscape.

Despite the small population and rural nature of the town, there was a movement to start a library. The first library collection that had been organized by the Pompano Beach Women's Club (incorporated and chartered in 1921 and reorganized in 1947) was destroyed by the 1926 hurricane. Volunteers from the women's club continued to operate a lending library in the 1930s under the leadership of Mrs. Frank Carson, mother of Emma Lou Olson.

The present Pompano Public Library got underway in April 1940 in a vacant part of the Bailey Building on the north side of First Street at First Avenue in Old Pompano. Fundraising activities had been conducted to gather resources for this community project. The library was relocated several months later to a building, rent-free, by William L. Kester on Old Dixie Highway, south of the FEC Road depot. The women's club and the Rotary club, under the leadership of Elwyn N. Powell, had initiated the movement to create a permanent town library. The first three librarians were Mrs. Isabella Klinger, Miss Effie Power and Josephine Peabody. Mrs. Klinger resigned in

Pompano Beach

Dennis McNab (*second from left*) proudly displays his catch (a sailfish) with his buddies and Captain Johnny Gramp at the Pompano Beach Hillsboro Inlet, identified as the Lighthouse Yacht Basin, in 1952. *Betty and Dennis McNab.*

The World War II Era

POMPANO BEACH

The Atlantic Boulevard Bridge opens to let boats pass through in 1960, looking south on the Intracoastal Waterway. The Pompano Beach Yacht Basin is to the left. St. Martin-In-The-Fields Episcopal Church is above the bridge on the right. *Pompano Beach Library.*

Atlantic Boulevard extends westward to the Everglades at the horizon in the 1960s. The bridge crosses the Intracoastal Waterway (*center*) while the Oceanside Shopping Center can be seen at the lower right. *City Clerk.*

The World War II Era

1942 to take a position at the University of Miami. Miss Power was a retired librarian from Columbia University. Individuals who helped form the library commission were Reverend George A. Foster from the Methodist Church, Mrs. T.N. Sue Alexander, Mrs. William H. Gertrude Blount, Professor E. Guy Owens and Effie Power. They were guided by a charter that was drawn up by the city.

The present library building at 1213 East Atlantic Boulevard was dedicated on June 4, 1952, on land donated by Kester. Josephine Peabody led the library until her retirement in 1967. In 1965, a $45,000 section was added to the present library. Mrs. Martha Schaff, Richard Yoder and Frank Trenery each followed in success as head librarians. Trenery was instrumental in establishing the beach branch in 1977. The present librarian is Janice Rolle.

One related organization that has contributed to the success of library programs has been the Friends of the Library. Organized in 1968, this group has promoted library services, educational programs and public interest in the Pompano Beach Library branches. The following have served as president of the Friends: Sue Alexander, Mrs. Hubbard, Purl C. Warner, Mrytle Eldridge, Alice Henderson, John Pinckney, Monroe Apfebaum, Beaulah McDonald, Sarah Revoir, Jean Johnstone, Pauline Burtz, Ruth Loughlin, Ruth Karlebach, Elinore S. Sullivan, Maria Marano, Nona Roy and Barbara Goodrum.

With World War II coming to an end in 1945, the American Legion organized the Sterling McClellan Post Number 142 to honor the son of Dr. George S. McClellan. Sterling McClellan lost his life in the war. The patriotic members engaged in fundraising activities to finance their new headquarters. They held a Bean and Pepper Jamboree at the Farmers Market on April 26, 1946. Member and organizer Henry V. Saxon stated: "The Jamboree was eventually discontinued after an ordinance was passed outlawing bingo. Bingo had been the main attraction." This great generation of veterans remembered well the sacrifices that had been made to defeat the dictators of the world. The United States, now the leader of the free world, faced newer challenges as it entered the cold war period. At the local level, the people of Pompano Beach would experience new problems in a rapidly changing society. The community that evolved after World War II contrasted with that of the pre-1941 period.

6.

The Modern Era

At mid-century, with a new reincorporated government only several years old, the City of Pompano Beach found itself clinging to the past while a bright new future awaited it. Frank H. Furman and his wife arrived in 1955. He helped shape the city as chairman and owner of Furman Insurance for more than half a century. The chamber of commerce announced in a promotional brochure that there were "two sections of town with each complementing the other in social and economic stability." The section west of Federal Highway (U.S. Highway 1) was the older section, largely agricultural and comprised of early settlers. To the east tourism, housing, small businesses and shopping centers were making an impact. The U.S. Census reported the 1950 population at 5,682. Broward County contained 83,933, and Florida counted 2,771,305. The distribution of people over sixty-five years old was 4.6 percent in Pompano Beach; it jumped to 21.6 percent twenty years later—a significant shift resulting from many retired people migrating from the North. In 1950 there were 912 telephone listings, a public school enrollment of 2,209 students and *The Town News*, a weekly newspaper, began publication. Pompano Beach was undergoing a fundamental transition. As late as 1950 community Christmas tree and Christmas festivities were still being held. Santa Claus arrived on Christmas Eve on the city firetruck with sirens blasting away. Children younger than twelve years of age received a gift and a stocking filled with candy and fruits. Carols were sung. The city clerk organized the holiday event, assisted by various civic organizations. The city was a cohesive, intimate unit, but that would change within a generation.

The Elks Lodge was established in April 1953 and became part of that transition when it received its charter. By 1955 the city's total assessed valuation surpassed $29,000,000. The $1.5-million Storyland Park, with thirty-eight buildings on fourteen and a half acres, opened in November 1955 for children and the young at heart across from Lake Santa Barbara at 1101 South Federal Highway. Sidney Caswell and Al Hennessy conceived the amusement park. Among the attractions were Little Bo Peep, the Three Little Pigs, Peter Rabbit, Jack and Jill, Three Men in a Tub, Humpty Dumpty, Little Miss Muffett, Sleeping Beauty, Jack and the Beanstalk and many others. It was not to last. Storyland Park was demolished in 1964. Bob Mayes of Mayes Chevrolet bought the property to expand his dealership. A few months later Hurricane Cleo destroyed the remainder of what was Storyland Park. Clint Fowlkes, son of Mayes Chevrolet executive C.J. Fowlkes,

The Norcrest Elementary School celebrated its fiftieth anniversary in 2007. These first grade students pose proudly with teacher Beverly W. Flohr for their 1960–1961 class picture. *Jack Musengo.*

said he remembered "parking extra cars back in Storyland. I remember the house of the Old Woman in a Shoe. It became a hangout for winos. In time everything had to be torn down." The Waterford Point condominiums now stand in this area.

Other contemporary attractions were Roger Brown's Miniature Horse Farm, south of the Hammondville Road entrance to the turnpike; Jones Brothers Reptile Farm in the Northwest part of town; and Creature Land, located north of town on Federal Highway. The First National Bank of Pompano Beach got underway with opening day deposits of $1.3 million. Citywide building permits had grown from 1,249,675 in 1950 to 7,177,159 five years later. Bus service began in 1956.

Road building, helped by billions of dollars in government aid, contributed to the rise of South Florida, with Pompano Beach a major beneficiary in the 1950s and 1960s. Interstate 95 paralleled Dixie Highway, U.S. 1 and S.R. A1A, linking the heavily populated centers of the Northeast with Florida. The Sunshine State Parkway, known as the Florida Turnpike and now the Ronald Reagan Turnpike, reached the Gold Coast as thousands of people celebrated its inauguration through Pompano Beach in May 1957, and the opening of the interchange west of Fort Lauderdale on January 25, 1957. Governor LeRoy Collins was there for the dedication. The 365-mile turnpike significantly increased tourism and commerce throughout South Florida. In the same year, the Chris Craft Corporation set up its world operations. The world's largest builder of motorboats offered eighty new 1958 models. Residents were invited to visit the plant. A complete code for zoning and land use was established and the assessed valuation

The Modern Era

Storyland Park opened in 1955 on South Federal Highway across from Lake Santa Barbara and featured a children's fantasy amusement park. It soon failed and was torn down in 1964. *Lillian Movsessian.*

increased to nearly $72,000,000 in the same year. The Indian Mound east of Santa Barbara at Southeast Thirteenth Street was dedicated as a passive park. The $2-million shopping center at Oceanside opened.

There was no organized recreation department before 1953. The Sand and Spurs Park, located today next to the Goodyear Blimp base at Northeast Fifth Street, began operating. The city's new $500,000 recreation center was attracting large crowds at its championship eighteen-hole golf course, modern clubhouse, swimming pool, tennis and shuffleboard courts and sports field. The swimming pool offered free swimming and lifesaving lessons. Adults were charged $0.30, children $0.15 for use of the pool. The golf course opened January 10, 1955, under the direction of Ray Daley as the professional manager. (The daily green fees at the municipal golf course in 1980 were listed at $5.00, and after 4:00 p.m. at $3.20.) Even the Southern Bell Telephone Company had to assign Sunday work crews to keep abreast with the growth. Terry Ford, at 1000 North Federal Highway, advertised "Customer Conscious Service" in 1957.

Industrial expansion began to make its mark. The March 1966 issue of *Florida Trends* praised Pompano Beach's industrial park as one of four municipal industrial parks in the state of Florida. It contained thirty firms and two thousand workers. By 1974 there were ninety light industries operating with fourteen thousand workers.

The housing industry enjoyed phenomenal growth. The Pompano Surf Club cooperative homes and apartments, built by Milton N. Weir and Sons, graced the east and west sides of S.R. A1A, south of Atlantic Boulevard. Mar Builders was advertising

Pompano Beach

Golf professional Ray Daly (*left*) and Bill Cahill, director of golf maintenance, can be seen at the Pompano Beach Country Club in 1968. The 1980 municipal golf course charged a green fee of $5.00 before 4:00 p.m. *Pompano Beach Library.*

its new 1957 Mar Deluxe and Mar Holiday homes at Lyons Park at prices starting from $12,900 (directions: from U.S. 1 turn west on McNab Road, which is Southwest Fifteenth Street, two miles north of Holy Cross Hospital). In 1958 the Mackle Construction Company of Miami was selling homes in Pompano Beach Highlands for $9,550 (Lime Beach model), $10,000 (Orange Beach model) and $10,655 (the Holiday Beach three-bedroom model). Monthly payments amounted to $70 a month with a $300 FHA mortgage down payment. Ninety-eight homes went up at Cresthaven; and Kendall Green homes got underway in 1959. The Pompano Beach Chamber of Commerce promoted the benefits of Pompano Beach city-living similar to the boosters of the 1920s, but this time there was a solid economic foundation for real growth. The chamber stated in 1957:

> *Yet all this sudden growth is by no means considered a "boom," for money being expended in Pompano Beach is more than visionary…it is cash on the line and in enormous quantities. Millions of solid dollars are being invested in the establishment of this new*

The Modern Era

Mount Calvary Baptist Church at Northwest Eighth Street is the oldest African American church in Pompano Beach. The building, shown here, was constructed in 1957 and replaced the old church. *Eunice Cason Harvey.*

> *City by cool-thinking businessmen who know what they are doing. It is private enterprise that is building this new city by the sea, backed not by promissory notes, but by cash. To invest now is to invest on a rising market.*

This time there would not be boom and bust. Economic growth was real and sustaining, especially with the support of the combined forces of local banks, real estate firms, builders and contractors, insurance companies, service organizations and a friendly government. Regulatory agencies helped to guide this economic development with concern for the general welfare considered the highest priority. It was an open competitive society and anyone willing to work could succeed, for Pompano Beach was not a "Four Hundred" type of society. "For the family seeking the glorious Florida way of life and a safe investment for its money, Pompano Beach is in truth a veritable Utopia," commented a local leader.

By 1960 tourist income had reached $5.1 million. The official 1960 Pompano Beach population skyrocketed to 15,992, a dramatic increase of 10,312 in ten years; Broward

The Goodyear blimp hovers over the beach while tourists and residents enjoy its recreational facilities in 1980. *Author Collection.*

County reached 333,946; and there were 4,951,580 Florida registered citizens. Service organizations played an important role in the development of the city.

The Pompano Rotary (International) Club was founded in 1930, during the depths of the Great Depression. With a population of 2,614 there were some individuals who argued that a club could not be sustained. However, early in the year H.M. Sours, Roland Hardy, J.W. Walton, H.L. Malcolm, S.C. Fox, H. Elmo Baker, R.H. Stevens and Alton Deal conducted the first organizational meeting at the Walton Hotel. The group's work led to the program for the charter presentation to the Pompano Rotary Club No. 3313 to be celebrated at the Hillsboro Club at the Hillsboro Inlet. Roland Hardy became the first president. In the first two decades membership was kept at twenty-five, but with competition from Kiwanis, Lions and other service organizations it was decided to increase membership to one hundred in the late 1950s. Charitable work expanded into many areas: helping to found the first public library, forming Boy Scout Troop #31, scholarship programs, Arbor Day ceremonies, Christmas parties for children, contributions to medical programs and endowments and a Rotary Foundation were established, etc. An early organizational bulletin item of August 27, 1937, stated:

> *Rotary Banned By Hitler*
> *At last the expected happened. Rotary has been told to get out of Germany. The Austrian-born house painter who has taken complete charge of that once great nation has decreed that any German who follows the teachings of Rotary is a traitor…It is not*

The Modern Era

surprising that Hitler sees no good in Rotary. "Service Above All" can have no part in the exploitation of Germany by Hitler and his gang.

Thomas J. Flynn was mayor and Emma Lou Olson was vice mayor of Pompano Beach when the third Elks Lodge #1898 home was dedicated at 700 Northeast Tenth Street, south of the air park, on March 4, 1984. At the time S. Louis Pachete held the position of exalted ruler of the lodge.

The establishment of the lodge goes back to 1952 when there were members of the Elks living in the area who initiated the movement for an official club, men such as C.C. Ratliff, W. Marion Walton, H.O. (Woody) Woods, Jack Howell, V. Paul DeFoe, Charles Keene, C. Keith Padgett and Frank Dunstatter. Meetings were held to lay the foundation. With the assistance of the Fort Lauderdale Lodge, one hundred and ten men signed on, enough for a charter. W. Marion Walton became the first exalted ruler, and April 30, 1953, became the official birth date of the new lodge.

The first home of Lodge #1898 was the old casino on the beach at Briny Avenue, just south of Atlantic Boulevard. A lease was attained from the city. The casino had been built by the Blount brothers in the 1920s and had been used for business and social gatherings. It was a tourist favorite. It had lockers and showers on the ground floor and a ballroom upstairs where dances were held. They were well chaperoned. The women's club met there for several years. The city acquired the property in 1940. The lodge began fundraising for the charitable work for which it is famous. It held a Christmas party at Kester Park for children on December 24, 1953. Dances, parties, picnics and patriotic events were conducted. On Thanksgiving night 1954, fire broke out and destroyed the building, ending the B.P.O. Elks Lodge #1898 on the beach. The members decided to start over again. It did not deter their good works and fundraising. A Christmas party was held on December 24, 1954, for the children at Kester Park, and a New Year's party was jointly sponsored with the American Legion.

Local farmer R.V. Jones came to the rescue. He donated a plot of land on which a new building would be constructed for a new Elks home at the new address of 2300 Northeast Tenth Street, on the east side of Federal Highway. A committee was formed to direct the project, bonds were issued and fundraising continued. The building was colonial-style, with four pillars and a trussed roof. The state and local lodges provided assistance. On March 13, 1956, the new home of the Pompano Beach Elks was dedicated with great fanfare. Membership had risen to nearly three hundred, and by the 1970s this facility became inadequate.

Plans got underway for a new location. Fundraising continued and bond sales were executed. On March 4, 1984, the new and permanent Elks lodge building was dedicated. There were twelve major rooms of thirty thousand square feet on 10.4 acres of land costing $400,000. The cost of the building came to $1,300,000. The Elks' home today is situated at the south side of Northeast Tenth Street near where the Sample McDougald House has been restored.

In February 1957 the Pompano Beach Drove #142 of the Benevolent and Patriotic Order of Does was instituted. Billie Woods was elected president, and soon after

President Billie Woods of the Pompano Beach Drove #142 of the Benevolent Order of Does, Elks Club, hops on the running board of a vintage automobile during the July 4, 1974, patriotic parade. *Rosemary Monard.*

The Modern Era

CITY OF POMPANO BEACH, FLORIDA
1964 City Commission

HAROLD S. HART — MAYOR

WILLIAM F PELSKI — VICE MAYOR

The Pompano Beach City Commission is the elected policy-making body and consisted of five members in 1964. Today the commission is comprised of five commissioners plus an at-large mayor. *Pompano Beach Library.*

attended the national convention at Idaho Falls to receive the charter. Woods served as president two more times, in 1967 and 1974. The history of the local Does is one of hard work and charity.

An organized Pompano Beach Jewish community, Temple Sholom, began in 1945. The original name of the congregation was spelled as "Temple Shalom," the

The Modern Era

conventional spelling, but it had to be changed to "Temple Sholom" because another Florida congregation had incorporated the same name. Abe Hirschman became the first president. According to the Jewish Genealogical Society of Broward County, Louis Brown (Braun), an immigrant from Russia, is believed to be the first Jewish settler in Broward County. He arrived in 1910 and opened Brown's Department Store on Main Street, now Federal Highway. Later, in Pompano in 1928, Abe Hirschman opened a dry goods store, the first known Jewish-owned business there, and seven years later Morris Hirschman opened Moe's Pharmacy in Old Pompano.

As Jews migrated to the area after World War II, many engaged in produce-related businesses as brokers. They were isolated in the agricultural community and realized their social and religious needs had to be met. The closest resources were in distant Miami. Anti-Semitism existed and the Holocaust was fresh in the Jews' collective memory. In 1961, after completion of an interview to lead the Pompano congregation, a rabbi discovered it was too late to drive back to Miami and he tried to rent a room at a nearby motel. He was refused even though vacancy signs were displayed. He went to several others and was rejected because the motels and hotels practiced flagrant discrimination against Jews. The rabbi finally was accommodated in a motel owned by a temple member. Upon returning to Miami the next day, he related the incident to the Associated Press and United Press International. The story was printed across the country, depicting Pompano Beach negatively.

The initial Temple Sholom congregation practiced their faith at the chamber of commerce building on Atlantic Boulevard, the First Methodist Church, Pompano Beach High School, the Garden Center and even an Italian restaurant (for Passover Seders). Its permanent and present home was dedicated in 1960. Rabbi Aaron Shapiro conducted services with approximately one hundred members. The Temple was designed in the shape of a Star of David. The education building was completed in 1969; the sanctuary opened in 1974; and the final expansion included the social hall, chapel, offices and lobby in 1989. The temple continued to grow through the 1970s, but as the city was built out and the western communities expanded it experienced a stagnant period. A new revival occurred from the 1990s on as the trends were reversed. Temple Sholom remains a vibrant center of Jewish religious and social life.

In 1975 St. Martin-In-The-Fields Episcopal Church celebrated its twenty-fifth anniversary. Located at Atlantic Boulevard and the Intracoastal Waterway, the parish began on October 24, 1950, when the Reverend Mark T. Carpenter, then rector of All Saints Parish in Fort Lauderdale, received authorization from the Right Reverend Henry I. Louttit, bishop of the diocese of South Florida, to start a mission in Pompano Beach. The first service of St. Martin's Church was held in the chamber of commerce building on Sunday, October 27, 1950. The first vestry organizational meetings had begun two weeks earlier. The first vestry was composed of Horace P. Robinson, Horace P. Edmonds, A.J. Musselman Jr., Eugene C. Hedges, Ernest Wooler, John B. Trumbull, Lynn B. Timmerman and John Olah.

William L. Kester and Mr. and Mrs. M.A. Hortt donated the land on which the church was built. The cornerstone was laid on April 29, 1951, and the first service in

POMPANO BEACH

The bar mitzvah ceremony of Ira Cor, son of Bess and Abe Cor, took place January 26, 1959, at the Pompano Beach Garden Club. It was the first bar mitzvah in Pompano Beach. *Florida State Archives.*

the church was held August 5, 1951. The vicarage was completed in May 1953 and the nursery and kindergarten four years later. St. Martin's became an official parish in May 1954. Reverend H.L. Zimmerman replaced the first rector, Reverend Don Copeland. By 1959 there were more than six hundred communicants, with more growth to follow. Thus, a new church was constructed and dedicated on Sexagesima Sunday 1962. More expansion occurred. The bell tower and chapel were dedicated June 26, 1966. The Reverend Canon H. Lyttleton Zimmerman, MDiv, became rector in 1956 and provided the inspirational leadership for the growth of St. Martin's Parish, which has served the community with outreach programs.

Our Lady of the Assumption Mission on A1A served the beach area at south Pompano and north Fort Lauderdale. As an increasing population began to shift westward across the Intracoastal Waterway, Archbishop Hurley of the Diocese of St. Augustine and Assumption Parish pastor, Michael Fogarty, prepared to build a school and eventually a parish on Federal Highway. Four teaching Franciscan sisters arrived from Illinois. Two weeks before the opening of the Catholic school in September 1958, Pope Pius XII divided the diocese into the Miami Diocese and the St. Augustine Diocese. Miami Diocese Bishop Coleman F. Carroll created St. Coleman's Parish on May 7, 1959, and

The Modern Era

In May 1964 Rabbi Rudolph conducted the first confirmation class at Temple Sholom, 132 Southeast Eleventh Avenue and Pompano Beach. In 2005 Temple Sholom celebrated its sixtieth anniversary Diamond Jubilee. *Florida State Archives.*

appointed Father Michael Fogarty of Assumption as the founding pastor of the new parish. Bishop Coleman Carroll and the new parish shared the same patron saint, St. Coleman of Cloyne.

Father Fogarty designed the complex that cost $350,000. The new school, now called St. Coleman's Parish School, opened its doors in 1959 to 247 students in grades one through seven. Enrollment grew while the number of religious teachers declined. In 1984 Sister Doris Dutko retired as the last resident religious principal. On October 30, 1960, Bishop Coleman Carroll dedicated the church building. In 1974 Monsignor Dominic Barry became the second pastor. He began the process of building a new church. To help pay for this and school expansion projects, Dr. Richard Porraro and several parents started the successful Italian Festival in 1984, which has continued to the present. Father Thomas Foudy became pastor in 1989.

A bright sign announcing St. Stephen's Evangelical Lutheran Church attracts travelers going to the beach along Northeast Fourteenth Street from Federal Highway. The church was organized on April 12, 1964, and groundbreaking for the first church and educational wing took place on May 1, 1966. The first congregants met in Pompano Beach High School for services and fellowship. Ground was broken again on January 25,

St. Stephen's Evangelical Lutheran Church projects a highly visible image to travelers on the Northeast Fourteenth Street Causeway on their way to the beach. The bell tower is to the right of the church. *Author Collection.*

A 1980 aerial view looking west includes the air park (*top*), Pompano Fashion Square (*center*) and the First Presbyterian (Pink) Church (*bottom left*). Federal Highway (U.S. 1) bisects the scene, running left to right. *City Clerk.*

The Modern Era

Images of the First Presbyterian (Pink) Church include *(from top left clockwise)* stained-glass windows, north side of sanctuary, church, Sea of Galilee window, children's sculptures and interior of the Robert Wells Young Chapel. *First Presbyterian Church of Pompano Beach.*

Visitors crowd the yacht basin at the Pompano Beach Hillsboro Inlet in 1960 during the World Series of Sport Fishing. The basin remains a main attraction for boaters and fishermen. *Florida State Archives.*

1976, for the new church building where the first service took place October 24, 1976. Above the entrance to the front doors is a Holy Spirit window. A stained-glass Holy Cross window, covering five hundred square feet, adorns the altar in the front of the church. The first pastor, Reverend David H. Schmid, served from 1964 to 1988. In 1990 the bell tower was erected and carillon installed. The pipe organ was purchased from the Conception Monastery in Missouri and dedicated in 1994. Other pastors who served St. Stephen's have been Reverends Donald Himmelman (1988–1994), Edward Benoway (1994–1999), Heiner Hoffman (temporary pastor 1999–2001), William M. Van O'Linda (2001–2006) and George Cruz (interim pastor 2006–Present).

Another nearby church that has become a fixture in Pompano Beach is St. Gabriel's Catholic Church at 731 North Ocean Beach Boulevard (A1A). Ground was broken on December 10, 1967, on the present four-acre site of prime property. The following year, June 29, 1968, Archbishop Coleman F. Carroll dedicated the thousand-seat church building. The first pastor was Reverend Thomas J. Goggin who presided over the first services at the Silver Thatch Inn several blocks south. Parishioner Edward J. Stack owned the Silver Thatch Inn and made it available for Sunday and daily masses, as well as providing a home for Father Goggin. Stack, elected to the city commission in 1965, became mayor for the next two years.

The Modern Era

The 1965 Class of Ely High School gathered for this group photo. Principal Blanche Ely is seated in the front row, seventh from the left. *Eunice Cason Harvey.*

The first sacristan at St. Gabriel's was Ursula Wall, and the first lector was Charles "Bob" Fogerty, who was ordained a priest at the age of seventy-five after his wife died. Other pastors who led the church were Msgr. Thomas O'Donovn, Msgr. Francis Fassalaro and Rev. Anthony Mulderry. At the other end of State Road A1A, two miles south, is the Assumption Catholic Church, which had been a part of unincorporated Pompano Beach but is now included in Lauderdale-By-The-Sea, and also serves Pompano Beach parishioners northward from Terramar Drive to Atlantic Boulevard.

The First Presbyterian Church of Pompano Beach, also known as the Pink Church, at 2331 Northeast 26th Street, celebrated its fiftieth anniversary in 2004. Its origins go back to an appeal from the Reverend Edward P. Downey the year before in an ad in the Pompano Beach *Town News* to those Presbyterians and congregationalists interested in forming a new church. Three men responded and met him at Martin's restaurant: Robert E. Bateman, Kenneth Daehler and John H. Weir. In early 1954, regular Sunday 7:00 p.m. vesper services began in the chamber of commerce auditorium. Next they began to hold Sunday morning services at the drive-in theater on North Federal Highway near where Terry Ford is now located. The theater was available because no movies were shown on Sundays. A portable pulpit was built and required six men to move it.

As the church membership moved forward, a building without air conditioning and heat went up near the Lighthouse Point Marina on property donated by Robert E. Bateman for the new Lighthouse Village Church, as it was called then. In 1956, three hundred charter members were received in the United Presbyterian Church, USA.

Pompano Beach

Attendance at Sunday services increased rapidly and it was decided to build a new church at a permanent location. The site at Northeast 24th Street was agreed upon and one thousand people attended the laying of the cornerstone on Thanksgiving Day, November 26, 1959. The edifice was dedicated November 6, 1960. An organ, piano and a new chapel (1980) were donated. Pink Church groups included the Anchors, Voyagers, Mariners, Women's Association, Bible Study, Christian Education and the St. Laurence Chapel (the first church-sponsored shelter for the homeless in Broward). In 1994 major renovations to Memorial Hall, the choir room, the upper narthex area and the administrative offices were made. Preschool ministries also advanced. Aware of the increasing number of diverse people in the area, a Brazilian Fellowship program began in 2004. A new master plan was agreed upon, *The Spirit of the Past—The Promise of Tomorrow*, the following year.

In 2000 the City of Pompano Beach population had risen to 78,191, of which 53,000 were white, 20,000 black and the remainder Latino and other. The Pink Church was one of three Presbyterian churches. The other religious group numbers were: twenty Baptist, nine Roman Catholic, nine Nondenominational, seven Church of God, four Apostolic, three Methodist, three Lutheran, three Christian, two Episcopal, one Synagogue and one Mosque. In north Pompano Beach, the San Isidro Catholic Church at 2310 Martin Luther King Boulevard has celebrated mass in English and Spanish since 1970. Iglesia Catolica is a multicultural parish. A new sanctuary was dedicated in 1999.

Pompano Beach celebrated its Golden Jubilee April 13–19, 1958, with a souvenir publication entitled *Gem of the Gold Coast* that briefly sketched the city's history and program events. A live historical "spectacle" was performed on six evenings at the new high school athletic field. *Pompano On Parade* was a John B. Rogers production written and directed by French Sensabaugh and Maryhelen Sensabaugh. It contained a prologue that honored the flag, Miss Pompano Beach as reigning queen, horsemen and flags of other lands, the high school band and majorettes and VFW and American Legion color guards. There were nine episodes tracing the early history, concluding with the grand finale statement: "Pompano on Parade is simply the United States of America on Parade—as symbolized by the Hillsboro Lighthouse with its power to guide those who seek peace and sanctuary."

7.
The Condominium Era

Advances in transportation, development of air conditioning, promotion of tourism, television displaying the wonders of sunshine in wintertime, economic opportunity and migration of retirees produced a remarkable population increase in South Florida in the decades following World War II. Many veterans who served in South Florida decided to return permanently. Although tourists were accommodated in small hotels and apartment buildings at the eastern part of Atlantic Boulevard, the Intracoastal Waterway and along the beach, a premium was placed on land values while a newer form of housing emerged in the 1970s—the condominium. Earlier the cooperative apartment had prevailed as an alternative to the private home, arriving in Florida in 1946. The Cloisters on State Road A1A, south of Atlantic Boulevard, was a popular cooperative in the 1950s, existing today amid towering condominiums. The cooperative declined because of its shortcomings; residents owned shares in the property and had exclusive rights to a residential unit, but decisions about the property were made by members' approval and sales were in cash. Yet 12,600 cooperative properties remain in contemporary Broward County.

Condominium expert Peter M. Dunbar has indicated that this form of real estate ownership had its beginnings at the time of the Roman Empire. Condominium means common ownership by two or more people. There are references to condominiums throughout the Middle Ages. The concept was legalized in France in the 1804 Napoleonic Code. By 1963 Florida had adopted the concept when the legislature passed Chapter 711, Florida Statutes, which laid the legal foundation for the creation of this unique form of homeownership. The condominium system is made up of three separate parts: first, the exclusive ownership of a single unit; second, joint ownership as tenants-in-common with others; and third, an agreement among owners for the management and administration of the total condominium property.

The condominium form of real estate gained immediate acceptance and outpaced the cooperative system of property ownership. By 2000 there were 246,335 condominium properties in Broward. Residents hold title to their unit, pay a maintenance fee for the upkeep of the common elements such as a pool, ballroom, parking, lobby, etc. and elect a board. A 1970 article in *Florida Trend* magazine described and popularized this style of living that was attracting buyers. More people now could afford to live in high-rise

The Kester Cottages on the ocean north of Atlantic Boulevard were an important tourist attraction in the development of Pompano Beach. This ad ran in 1940. The cottages were replaced by the construction of high-rise condominiums. *First Presbyterian Church of Pompano Beach.*

condominiums and adjust to the shrinking supply of property (especially on or near the ocean) and rising land values. The land was used more efficiently with costs being shared and apartments being built at higher elevations. (The time-share apartment concept developed later and would further allow people to live on or near the beach, at least for one week in the year.) The Ocean Colony condominiums, built in 1969 in unincorporated Pompano Beach on South Ocean Boulevard (now a part of Lauderdale-By-The-Sea) was one of the first in the area and was selling apartments for prices ranging from $29,400 to $51,700. The Sea Monarch and Ocean Monarch were also among the earliest.

Pompano Beach, lying within the Gold Coast, now became a part of the Condominium Coast. Suddenly there was a flurry of activity as developers seized opportunity after opportunity to meet the demand for condominium-style living. Within a few years high-rise structures were lining the east and west side of State Road A1A, north and south of Atlantic Boulevard, at the Intracoastal Waterway and along the new causeway at Northeast Fourteenth Street. This phase of construction coincided with the demolition and transfer of the famous Kester Cottages. Land was cleared, architectural plans created and approved, heavy equipment moved in and employment opportunities abounded. The city leaders eagerly awaited the revenue that would follow. Related businesses would provide services and benefits to sustain economic growth. Starting in the late 1960s and continuing into the 1980s the following high-rise condominiums rose

The Condominium Era

The 1970s condominium era was marked by the construction of the Renaissance I (*left*), Renaissance II (*right*) and Renaissance III (*left foreground*). The old Holiday Inn Resort (*left*), later called Ramada Ocean Resort, was destroyed by Hurricane Wilma. *Author Collection.*

along State Road A1A, Ocean Boulevard and the Intracoastal Waterway: Admiralty Towers, Aegean, Atlantis, Bermuda House, Christopher House, Granada House, Tiffany Gardens, Nassau House, Pompano Beach Club, Triton, Waterbury, Parliament House, Renaissance I, Renaissance II, Renaissance III, Criterion, Claridge, Gabriel Towers, Sea Point, Silver Thatch, Trade Winds and Jamaica House. Storyland, the fantasy entertainment park at South Federal Highway, was torn down to make way for high-rise condominiums. The Renaissance I at 1360 South Ocean Boulevard was ready for occupancy in June 1974, with apartments starting at $52,000 and maintenance at $60 per month. It became the second highest structure in Broward County. State Road A1A consisted of two lanes, and there were no sidewalks. Sales were so slow that the builder, Motek Messer, offered free Cadillacs as an incentive to buy. Cocktail parties were held every Sunday in the Renaissance I Tower Sky Lounge on the twenty-ninth floor. Because of an easement, the building was the first to allow public access to the beach through its service lane on the north side. The Fort Lauderdale *News and Sun-Sentinel* noted in the June 21, 1975, edition that the Renaissance I rivaled "anything to be found from Miami Beach to Jacksonville."

In the 1983 Summer/Fall edition of *The Best of Lauderdale and the Gold Coast* the Criterion, north of the Renaissance I on A1A, also on the ocean side, ran an advertisement entitled "Ageless Splendor" as a forty-six-residence condominium that was not "designed to be typical. The hands of artisans have crafted a décor drawn from

Pompano Beach

Fisherman's Wharf pier at the beach can be seen with condominiums in the background in 1969. The low-rise building (*background center*) is the Sands Harbor Hotel Resort west of State Road A1A. *City Clerk*.

The Condominium Era

the past that combines warm rich woods and understated accents to produce a mood of traditional stately living." This luxury ten-story condominium containing 2,690- and 3,185-square-foot residences offered units at prices starting at $300,000.

In the west, Leisure Village, built in the years 1968–1970, featured one- and two-story residential and condominium homes on North Copans Road. It had a golf course, and the residents had to be fifty-five years or older. There were two eight-story buildings at the Cypress Bend condominiums, east of Powerline Road, constructed in this period. The Palm Aire development began in the 1950s. Harold Brolliar and George Palmer bought 440 acres of land west of Powerline Road and south of Atlantic Boulevard and built a golf course, clubhouse and motel.

In 1968 the Palm Aire development began the process of merging with Pompano Beach. Annexation took place in 1971, nearly doubling the population of the city. Marvin Orleans, a Philadelphia land developer, acquired this small golf course community, bought more land and by the middle of the 1970s Palm Aire boasted over five thousand residences, dozens of towers, five golf courses, twenty swimming pools, a large tennis complex, a cluster of small hotels and later a world famous health spa that hosted such personalities as Elizabeth Taylor, Goldie Hawn and Bert Parks. Giordano's Italian Restaurant, at Loehmann's Plaza next to the Palm Aire Cinema, advertised a 1980 early bird dinner at $3.50 and a Thanksgiving special at $7.50. In 1983 a remarkable event occurred when more than $1,500,000 worth of bonds at Palm Aire was purchased to go to the industrial development of Israel. Fund drive chairmen Sam Kaplan and Maxwell C. Raddock proudly proclaimed that Palm Aire was the largest Israel bond-producing country club in South Florida. Today the community boasts five golf courses, two full-service clubhouses, restaurants and sports lounges, thirty-seven tennis courts and the Palm Aire Golf Academy.

The demand for new services by the increased population was met with new businesses. In 1966 developer Leonard Farber purchased sixty acres of land, valued at nearly two and a half million dollars, to construct a state of the art shopping mall. The land was part of the Pompano Beach Airport, south of Copans Road and west of Federal Highway. Named Pompano Fashion Square, groundbreaking for the area's first enclosed mall took place on August 1, 1968, with dignitaries and the curious present. Mayor Edward J. Stack presented Farber with the key to the city. Bud Boyer chaired the event. Altogether Farber, who developed forty-five malls and shopping centers, completed Pompano Fashion Square in 1970 (with one hundred and eight stores) and the Galleria Mall a decade later in Fort Lauderdale. The mall at Copans Road and U.S. 1 was renovated in 1985 and renamed Pompano Square. Woolworth's joined the established anchor stores of Burdine's, Jordan Marsh, Penney's and Sears the following year. An art deco theme was complemented with a tropical flavor of pastel pink and turquoise. Unfortunately, the newly designed Pompano Square mall became obsolete twenty years later. A new mall, called Pompano City Center, replaced it with an open-air mall with additional stores, services and restaurants.

In 1966 the city government consisted of Stewart R. Kester as mayor, and Commissioners George S. Fivek, Robert C. Fuller, William Pelski and Edward J. Stack.

The Condominium Era

Mayor Edward J. Stack (*right*) hands the key to the city to Leonard Farber, the developer of the Pompano Fashion Square shopping center on August 1, 1968, at the groundbreaking. *Pompano Beach Library.*

Groundbreaking gets underway for the construction of the Pompano Fashion Square on August 1, 1968. Dignitaries prepare for the ceremonies at the site. *Pompano Beach Library.*

The completed Pompano Fashion Square shopping center dominates this view in 1980. Federal Highway is to the left; Copans Road is in the center. Condominiums can be seen in the distance along the coast. *City Clerk.*

The Condominium Era

The city manager was Elsworth Hoppe. Stack served on the commission from 1965 to 1968, holding the position of mayor in 1967 and 1968. He was elected Broward County sheriff in 1968 and held that position for ten years. Stack became the first Pompano Beach resident to be elected to the United States Congress, representing the 12th Congressional District for the years 1979 to 1981. A New Jersey native, born in 1910, he received a law degree from the University of Pennsylvania, joined the coast guard during World War II and moved to Pompano in 1957. The year 1966 witnessed the Fairview area becoming a part of the city. The city's population more than doubled in the decade, rising from 15,992 in 1960 to 37,724 in 1970. Light industry and commerce expanded along the Powerline Road corridor.

Yet there were quality of life and environmental concerns over so much rapid development as early as this period. The 1971 City Annual Report stated that the year before was the biggest ever in the total valuation of building permits, $92,177,167. The report continued:

> *In 1971, finding itself becoming burdened with a vastly expanding population (135% growth in the last decade) accompanied by a building construction boom, the City Commission amended the City's Zoning Code to control the number of family dwelling units that can be constructed on a given parcel of land. The legislation of such "density laws" is becoming more prevalent with the rising concern over pollution and environmental protection. With a projected population growth of 100% or more for the next decade the burden upon municipal services (i.e., sewers, fresh water, traffic-ways, police and fire protection) will be overwhelming and the passage of the density control ordinance is an initial step toward a comprehensive plan and orderly growth for the City of Pompano Beach.*

The commission acted based on the information the city planning department had gathered from public meetings and consultants. The density ordinance had two goals: to reduce the population load upon the land; and to increase the amount of open space and green area on a parcel of land. The city's policy was instituted at a time when condominium construction was beginning.

Nevertheless, expansion continued as the policy was eroded and was not applied to the beach area. One of the most important elements to coincide with all this period's growth was the two-million-dollar, one-story elongated Oceanside Shopping Center at the northwest corner of Atlantic Boulevard and State Road A1A. Because of its prime location and high visibility it was unavoidable as a destination point. Rather than going west to cross the new Atlantic Boulevard Bridge built in 1955 to shop on the mainland, quality shops and restaurants were available to the locals and tourists east (and west) of the Intracoastal Waterway on the barrier island.

The Oceanside Center was opened the last weekend of November 1956 amid much fanfare. The merchants association, consisting of twenty-seven store owners, provided continuous entertainment, a free 1957 Buick and other prizes, television personalities, performances of the Pompano Beach High School Band, live WWIL radio broadcasts and a Santa Claus arrival.

Pompano Beach

A postcard scene features the Oceanside Shopping Center soon after construction in 1956 at the corner of Atlantic Boulevard and State Road A1A. The Intracoastal Waterway and boat basin are at top center. *Lillian Movsessian.*

The old Oceanside Shopping Center as it looked in 2000 before it was demolished and replaced by the modern high-rise OceanSide Plaza luxury residences in 2007. *Author Collection.*

The Condominium Era

In 1972 Louis and Ann Iandoli, who had been frequent winter visitors to Fort Lauderdale, bought Oceanside from original owner-developer James B. Kirby for two million dollars. A decade later Oceanside increased in value to ten million dollars. Kirby was the inventor of the Kirby vacuum cleaner. He was a Midwesterner who in 1947 started to spend winters in South Florida. Seven years later he bought four acres of land that was to become the Oceanside Shopping Center. There were only a few small apartments nearby, the Yachtel marina and the Kester Cottages. Louis Iandoli was a successful fuel-oil dealer from Brooklyn. He died in 1982. His wife Ann continued to operate the center; she also owned an elegant beachwear-swimsuit shop.

In 1959 restaurateur George Harris opened the popular Harris Imperial House Restaurant on the east side of A1A. Other restaurants and shops were opened at the four corners of the intersection. More stores, services and restaurants were added to the original Oceanside Shopping Center. In contrast, in the original settlement, the old red, white and blue "Put and Take" landmark service gas station at 201 Northeast First Street in Old Pompano was razed to make room for a church parking lot. The service station was started by Gene Hardy in 1934 and later operated by his sons Charles and Noel. Gas and groceries were sold; no credit was allowed. "You put down your money and took what you wanted," explained Noel Hardy.

Things were different at the east end of Atlantic Boulevard by the ocean. A unique pylon, a new landmark standing on four legs, marked the Oceanside Shopping Center. It was constructed in mid-century modern architectural style. Decline set in as Oceanside gradually lost its appeal at the turn of the century. New owner Atlantic Point Developer took the pylon down on January 18, 2005, and destroyed it. Attempts at preserving it failed. WCI Communities, Inc. purchased the property and built a high-rise condominium containing a 186-residence tower on the site, naming it "The Plaza at OceanSide." The new OceanSide complex features restaurants, cafés, boutique shops and a spa and hotel. It is highlighted by forty thousand square feet of indoor and outdoor amenities. WCI Communities asserted in a 2007 publication that the "seaside town has been one of the best kept secrets on the map for years and is starting to make its debut with new area developments like OceanSide."

Major league baseball came to Pompano Beach in 1961. The Washington Senators agreed to make the city's municipal stadium their spring training home base. It was to be the fourth major league team within commuting distance, the other three teams being the New York Yankees at Fort Lauderdale, the Baltimore Orioles in Miami and the Kansas City Athletics in West Palm Beach. When the old Washington Senators moved to Minneapolis-St. Paul to become the Twins, an expansion team replaced it in the District of Columbia. The new Washington Senators, managed by Mickey Vernon, persuaded Pompano Beach to modernize the stadium, clubhouse and press box. The chamber of commerce contributed $5,000 to the Senators, and the city guaranteed $15,000. There was to be an even split of 50 percent on concessions.

The Washington Senators became the Texas Rangers in 1971, but remained at the Pompano Beach spring training site until 1986. The team had a mediocre record over the years, although it was managed by outstanding baseball personalities such as Gil

POMPANO BEACH

This changing scene captures the high-rise development at the beach as the new Oceanside Plaza nears completion April 29, 2007. *Author Collection.*

The Washington Senators used municipal stadium as a spring training base from 1961–1970, and continued there as the Texas Rangers until 1986. Fans watch this Washington Senators game in March 1970. *Pompano Beach Library.*

The Condominium Era

Frederick L. Van Lennep (1911–1987) brought night harness racing to Pompano Beach in 1964. He also established a golf course on the grounds. Pompano Park is in the background. *Pompano Park Harness Track*.

Pompano Beach

Leading driver Bruce Ranger guides Somebody Stop Me to victory in the one-mile pace at Pompano Park Harness Track on July 5, 2000. Joe Napolitano was the trainer. *Pompano Park Harness Track.*

The Condominium Era

Pompano Beach

The Northeast Fourteenth Street Bridge over the Intracoastal Waterway was dedicated January 31, 1968. Mayor Edward J. Stack presided. This 1969 photo shows a relatively undeveloped area. *Pompano Beach Library.*

Hodges, Ted Williams and Nellie Fox. The city was also the summer home of the minor league team in the Florida State league during this period. Oddly, baseball commissioner Bowie Kuhn, an avid fan of the original Washington Senators, allowed the expansion Senators to leave and become the Texas Rangers in 1971.

Minor league baseball teams in the Florida State league have also been represented in this period. The Pompano Beach Mets have played here (1969–1973); Pompano Beach Cubs (1976–1978); and Pompano Beach Miracle (1990–1991). Mike Veeck guided the Miracle with promotional stunts that succeeded only briefly. He used a Golden Retriever as a batboy and the club's goodwill ambassador.

The John Knox Village is an accredited life-care retirement community at Southwest Sixth Street. It provides lifetime housing, home maintenance, social activities and on-site nursing care. It arrived in Pompano Beach in 1967 to fulfill a need for senior citizens by providing a full range of independent living, assisted living and nursing home options. The sixty-four-acre facility, with tropical landscaping and well-planned lakes, has a population of more than 1,100 senior residents. Following payment of an entry fee, residents are entitled to the use of the assisted living facility and the John Knox Health Center. The new main entrance, adjoining a new Heritage Tower nearby, is now located at 400 John Knox Village Boulevard (Southwest 3rd Street).

"Starting Gun is Readied for Pompano Park" was the headline in the *Sun-Sentinel's* special informational edition of January 22, 1964, saluting the impending opening of the new harness track in Southwest Pompano Beach. It helped to transform the city from the "Winter Vegetable Capital of the World" to the "Winter Capital of Harness

The Condominium Era

A 1970 Pompano Beach postcard view captures the beautiful coconut palms bordering the beach and fishing pier. The new Sea Monarch condominium is to the left. Hillsboro Lighthouse can barely be seen in the distance. *Florida State Archives.*

Racing." The actual opening of the new $5.5-million Pompano Park Harness Track took place on February 4, 1964, for a forty-six-night inaugural season on its 331-acre site south of Atlantic Boulevard and east of Powerline Road. Despite two inches of rain that fell on opening night, attendance reached 4,011 and the handle was $108,154. It was the same site where the first thoroughbred track failed in 1926. During World War II the old grandstand was dismantled and used as part of the Gulfstream Park Racetrack structure. Stock car races and boxing matches took place at the original track in the 1940s.

Frederick L. Van Lennep, a Philadelphia businessman and graduate of Princeton, and his wife Frances Dodge Van Lennep, purchased the track property in 1953. Both were determined to build a Standardbred harness industry. Barns and a half-mile track were constructed and a harness horse winter training center emerged. The Van Lenneps were the owners of the second largest Standardbred farm in the world, Castleton Farms in Lexington, Kentucky. Frances was the daughter of John Dodge, the founder of the Dodge automobile company. The Van Lenneps wintered at their oceanfront home in Delray Beach. They shipped their horses down by railroad. Other owners followed.

Opposition rose to prevent the track from being built, mainly based on moral grounds. Pompano Beach City Mayor Woodrow W. Cheshire urged Governor Farris Bryant not to sign the Broward County Harness Racing Bill. He said, "We should have no gambling in the State of Florida" because the horse trotting track would attract the "wrong kind of people." Opposition failed as the city commission approved harness racing by a four to one vote. The state enacted similar legislation.

Pompano Park Harness Track has been home to the world's greatest horses, trainers and drivers. It remains the only nighttime horse racing in Florida. In 1979 and 1980 Niatross was horse of the year. On December 27, 1980, Niatross, trained and driven by Clint Galbraith, raced before a record crowd of 18,451, while more than five thousand fans were turned away for lack of parking. Through the 1980s there was a complete golf course and clubhouse within its boundaries. Vice-president Allen J. Finklestein said the track "enjoyed one of its best seasons. February as a record-breaker." Nevertheless, throughout the next several decades a decline in attendance set in, as was the case at all tracks.

The purebred American miniature horses are based at the Pompano Park Harness track and serve as ambassadors for harness racing. They are popular with children who get to hug, pet and ride them on special occasions. The Isle of Capri Casinos purchased the track in 1995 and sold the property (the original training track) north of Southwest Third Street. Twelve years later, it offered Las Vegas-style slot machines.

In 2005 Broward County voters had decided to allow slot machines following the passage of an amendment to the Florida Constitution permitting such choice. On April 5, 2007, the newly named Isle Casino & Racing at Pompano Park opened its doors for business at the two-story, 157,000-square-foot building that can accommodate three thousand people and features four restaurants. Easy access is available connecting the casino to the harness racetrack. With more than 220 acres of land, parent company Isle of Capri Casinos plans to add a convention center, hotels, shopping areas and housing.

8.

Toward the Millennium

The 1983 observance of the Pompano Beach Diamond Jubilee was a major event for the people of the city. A special illustrated 146-page *Commemorative Book Celebrating 75 Years, 1908–1983* was published in a limited edition on June 15, 1983. Stewart R. Kester served as general chairman of the Diamond Jubilee Executive Committee assisted by E. Grey Webb as president, Owen T. Meyers as vice-president, Hazel Armbrister as secretary, Clint Fowlkes as treasurer, along with Wilton Banks, Stella Kern, Adolph J. Kissileff, Tommie Lee McBride, George Sundstrom and Scott Taylor. Additionally, there were eleven divisional chairpersons complementing this organization leadership group.

Broward County's Tourist Development Council agreed to contribute $50,000 for public barbeques, dances and musical events on the beach and at Pompano Park Harness Track, State Farmers Market, Pompano Fashion Square and the municipal park. Sue Hatcher was the president of the nonprofit corporation that raised $85,000 to stage the pageant.

Local historian Lorena Hardin Robson was called on a second time to help chronicle the history of Pompano Beach. She was there for the fiftieth anniversary of the city to lead that important task. Robson's remarkable life and career mirrored the various stages of town history. She was born in 1907 in Daytona and moved with her family to Pompano three years later. Her father, Ruben Augustus Hardin, worked for the FEC Railroad, building depots and laying trestles. He was one of the original town contractors. At first the Hardin family lived on the Saxon farm west of Dixie Highway, but eventually constructed a home where the First Baptist Church stands. The house was destroyed by fire in 1918 and the land was donated to the church. As Robson grew older, her first job was with the Bank of Pompano until it failed in 1931. She witnessed economic dislocation and how the sturdiest of settlers survived. She then moved on to spend more than four decades working for the city in various capacities as treasurer, clerk, tax collector, tax assessor and voting registrar. Her knowledge of the city's inner workings was unparalleled, and that knowledge was put to good use in the production of an unpublished manuscript in 1974. Lorena Hardin Robson remembered Old Pompano as a close-knit, provincial town. She learned how to row a boat on Lake Santa Barbara. She said, "We used to have dances and activities centered around the two churches. I grew up Baptist and married Methodist."

A 1980 dedication marker at Founders Park lists the officers and trustees of the Pompano Beach Historical Society and Museum. *Author Collection.*

The Pompano Beach Historical Society and the Museum are based in two Kester Cottages that were transferred from the beach to this site at Founders Park. *Pompano Beach Library.*

Toward the Millennium

One of the most successful ongoing oceanfront events is the Pompano Beach Seafood Festival. A large crowd gathers at the beach on April 28, 2001. *Pompano Beach Chamber of Commerce.*

When all the planning was completed for the seventy-fifth anniversary, six hundred people were chosen to serve on sixty-two committees that produced an extensive jubilee calendar of events that ran from May 31 to July 4. A live production of *Pompano Beach: A Glitter of Gold* by Don Dalton was performed for four nights (June 28–July 1) at the municipal stadium. Other events that took place were: a barbershop harmony show; a tennis tournament; a horse show with a country and western band hosted by the Sand and Spurs Stables; Interfaith Day Celebration at the ballpark; a golf competition; Jubilee Music Festival; promotional tours of Ely High School, Oceanside, Town Center and Royal Palm Plaza; bicycle races; a Pioneer Day picnic at the Elks Club; a regatta; and other events too numerous to mention. The jubilee celebration closed on July 4 (Monday) with an evening Independence Day program at the municipal stadium, followed by fireworks. The most enduring result of the jubilee was the publication of the commemorative book, which became a permanent record of the city.

Such an appreciation of the past represented a high point for Pompano Beach, a city older than Broward County. But the future offered new challenges. The dramatic population increase, construction boom, expansion of light industry and tourism continued to characterize Pompano Beach as the twentieth century moved to a close. Yet the city did not have the cachet that cities like Fort Lauderdale, Miami Beach and Boca Raton possessed. Whether such a mark of distinction was necessary, Pompano did attract more people and investments. The Goodyear Blimp that was based at the air

Pompano Beach

Three days of fun and fishing were featured in the nineteenth Pompano Beach Fishing Rodeo in May 1984, when $250,000 in prizes were awarded. The first rodeo was held in May 1965 and is a continuous event for anglers. *Author Collection.*

Toward the Millennium

The Old Pompano intersection at Atlantic Boulevard and Northeast First Avenue cannot hide its decline in this 1967 scene. Post-World War II growth shifted to the suburbs, beach and new shopping malls. *Pompano Beach Library.*

park helped to generate notoriety. But the city lacked a major cultural center and sports center that would accompany a professional sports team. This original agricultural community that experienced so many expansion patterns still retained its small-town image. Although the charming Kester Cottages north of Atlantic Boulevard on State Road A1A were either relocated or demolished, mom and pop motels, mostly twenty rooms or less, still dominated the local tourist destinations. Many small businesses existed despite the Pompano Fashion Mall.

Perhaps it was not necessary to mimic glitzy neighboring urban centers. A unique quality of small-town living prevailed. Pompano Beach boasted many prime assets within its borders: a beautiful beach with parking lot, a magnificent recreational facility along Federal Highway offering riding stables, tennis, a golf course, aquatics, athletic fields, jogging paths and an airfield benefiting businesspeople and commuters. The turnpike and interstate highway, with a manageable local road system, made the city accessible to business and tourism. The largest single attraction in this period was the Pompano Park Harness Track. Boating and fishing were important attractions, as were

POMPANO BEACH

Toward the Millennium

Looking south, crowds gather at the Atlantic Boulevard Bridge and the Intracoastal Waterway for the 1966 Christmas Boat Parade. Since then major changes have occurred on the west side of the bridge, at the top. *Pompano Beach Library.*

Florida Governor Lawton Chiles (*fourth from left*) paid tribute to the Mount Calvary Baptist Church and its congregation in 1991. *Eunice Cason Harvey.*

the annual Christmas Holiday Boat Parade, Seafood Festival and Fishing Rodeo. Citing a news item of April 7, 1986, on any given day during the most recent high season, population counts varied between 110,000 to 130,000, while the previous summer daily counts averaged 73,000. It was a very successful tourist season, along with reasonable numbers for the off-season. For the same period, Broward County tourism declined.

However, simultaneously there was considerable concern expressed over the gradual decay of the Old Pompano business center by the FEC Railroad at Flagler Avenue following World War II. It was so bad that blight dominated the area by 2000. The shifting economy and population eastward to the ocean and westward to the suburbs produced a new dynamic locally and nationally. The "inner city" could not withstand these changes without serious consequences. Reflecting and contributing to this trend was the demolition of the FEC Railroad passenger station that ended passenger service.

In 1974 another old landmark, the Pinehurst Hotel, was demolished. It had been built by Harry McNab and Robert McNab in 1924 at the 350-acre Pinehurst-By-The-Sea site near Atlantic Boulevard and Federal Highway. The following year the Kneeland residence, built by Hiram F. Hammon, was razed. The home, built of Dade County pine, faced Northeast First Avenue.

Pharmacist George Hamilton worked at and eventually owned a drugstore at Northeast Flagler Avenue in 1928. He witnessed firsthand a lifetime of growth and eventual deterioration. The drugstore contained a soda fountain, terrazzo floor and wooden cabinet and exhibited the charm of an intimate country store. It was located

Toward the Millennium

This man is displaying a Portuguese man-of-war at the beach. As a member of the jellyfish family, it resembles an oblong balloon with tentacles that can cause serious illness if touched. *Pompano Beach Library.*

across from the vibrant business activity at the old farmer's market. He knew all his customers. As time went on future customers began to patronize the Beachway, Beacon Light, Oceanside and Pompano Fashion Square shopping malls. Many stores on Flagler Avenue closed and were converted to warehouses creating an undesirable environment. Hamilton said, "I don't know what will happen but I am hopeful that in my lifetime this area which has gone up and down and come back will be revitalized." He died in 1982, failing to realize his wish. Pompano Beach city planning director Fred Kleingartner believed a joint effort between the private and public sectors should be coordinated to revitalize the old business district. The city lacked a redevelopment authority.

Another community concern was the sand erosion at beachfront property caused by overdevelopment and weather conditions. Some structures were losing land so rapidly that homes and motels might be destroyed in the 1950s and 1960s. Beginning in the early 1960s the city responded by spending $70,000 to renourish the beach by dredging 150,000 cubic yards of sand from Hillsboro Inlet and depositing it southward to Pompano Beach. Again facing the same problem, this time in 1981, a multimillion dollar project got underway dredging sand from the Hillsboro Inlet and moving it as far south as Lauderdale-By-The-Sea and extending the shoreline about one hundred feet at Pompano Beach. New beach renourishment is planned.

Pompano Beach

Congressman Paul Rogers presented the national bicentennial flag to Mayor William J. Alsdorf October 17, 1975, in preparation for the two-hundredth anniversary of the nation's birth. At the local level the Pompano Beach Bicentennial Committee was inaugurated, and according to the city commission proclamation, one of its goals was to help "raise funds for a museum." In 1974 the Pompano Beach Historical Society received a charter and elected its officers. The first Antique Show was organized to promote and raise funds for the museum. The first meeting of the Pompano Beach Historical Society took place at the library February 28, 1974. Mrs. David Ballou became founding president. The first antique show of November 29–December 1, 1975, raised funds to collect all original records and to chronicle the history of the city. Stewart R. Kester and Robert Kester donated two Kester Cottages that were relocated from the beach to Rustic Park north of Atlantic Boulevard to be the home of the historical society. It was stocked with memorabilia and artifacts to be displayed for public viewing.

By 1983, however, there were no references to black settlers or leaders at the museum. Only a portrait of educator Blanche General Ely was hanging on a wall with other town pioneers. It has been stated before that black families were early settlers who contributed to the growth and success of Pompano Beach. The historical society recognized this error and began to include blacks with the addition of award-winning actress Esther Rolle.

Another black leader who has played a major role in contemporary public affairs is E. Pat Larkins. Born in Pompano on April 29, 1942, and married to retired schoolteacher Bettye Lamar-Larkins, he became the second African American elected to the Pompano Beach City Commission and the eighth African American local official in Broward County in 1982. He served nineteen consecutive years as city commissioner, an unprecedented seven terms as mayor and three terms as vice mayor. In 2001 he failed to win a seat on the Broward County Commission. Two years later he was elected to the city commission and continues to hold that position today, representing District 4. He has been honored with a civic center named after him.

Larkins has had a multifaceted career. A graduate of Ely High School, he matriculated at Tennessee State University, was awarded a Ford Foundation Fellowship, became certified by HUD as a Housing Development Specialist and created the Broward County Minority Builders Coalition where he serves as CEO. He is president and partner of Malar Construction, a state licensed contractor. As a leader in the civil rights movement he is a lifetime member of the NAACP, Ely High School Advisory Committee, Florida Black Caucus/Local Elected Officials and served on various other committees representing minority rights.

Karl Weaver (1937–2006) actually preceded Larkins on the Pompano Beach City Commission and was the first African American to hold that position. Weaver had been elected in 1973 on a citywide ballot before single-member districts were established. He was active in many civic affairs, particularly the historical society and the Sample-McDougald House Preservation Society.

9.

Contemporary Pompano Beach

In 2005 Pompano Beach received the All-American City Award from the National Civic League, America's original advocate for community democracy, founded in 1894. The All-American City Awards began in 1949 to recognize the efforts of extraordinary communities. It is the most successful National City League program.

Nevertheless, as the city expanded from a few hundred people at the beginning of the twentieth century to a population of more than 101,000 today, the character and composition of the community changed dramatically, some of that change being unenviable and occurring in Old Pompano. Basically, it became apparent that the old downtown area at the northeast section of Dixie Highway and Atlantic Boulevard was in need of restoration. Aware of this need, the city received several grants from the county to plan for redevelopment. Steps were taken. A farmer's market began operation on Saturday mornings in the area. Since 2001 the Pompano Beach Historical Society and the descendants of the early settlers have conducted "Old Pompano Historic Home Tours" to generate interest.

A look at the physical composition of Old Pompano through its houses presented a truer vision of the community. Many of the surviving houses and their owners represent an important part of Pompano's past. Thus a movement was initiated to popularize those houses that possess historical significance and physical beauty. Some of the original Kester Cottages constructed seven decades ago have been destroyed or moved elsewhere. Fortunately, several have been preserved to serve as the home of the Pompano Beach Historical Society. Present and future generations will be able to see and experience a lifestyle that these cottages represented during an earlier time. They also honor the man who built them.

The community effort to preserve the Sample-McDougald House became a pivotal event in contemporary Pompano Beach. This architectural relic is a critical link to the past. Community leaders were committed to saving a part of the past that was rapidly disappearing. The McDougald family donated the house to the newly created Sample-McDougald Preservation Society in 2001. Fundraising began and volunteers contributed their time to restore the house. Originally built at 3161 North Dixie Highway, south of Sample Road, the house was completely surrounded by farmland at a time when Dixie Highway was the only road between Deerfield Beach and Miami that brought tourists

POMPANO BEACH

The Sample-McDougald House was in disrepair in 2001 when it was moved to its present site at 450 Northeast Tenth Street in 2001. It has been restored to its original condition and will become a museum. *Author Collection.*

The Cap Campbell House is the oldest house in Pompano Beach. Built in 1910 on Northeast First Street, the house was rolled on logs in the 1920s to its present site. Campbell was a farmer, politician and realtor. *Author Collection.*

Contemporary Pompano Beach

and realtor Harley Cap Campbell. In addition to the Campbell family, other owners who have resided were the Guyton family, Strickland family, the Merritt family and present owners Alan and Doris Price. Each owner made improvements to add amenities in attempting to maintain the house's local architectural integrity. The architectural style is considered frame vernacular with wood construction (Dade County pine) by local craftsmen. The Cap Campbell house has a distinctive Florida tropical feel.

One of the most unique homes in Old Pompano is the Wallace Robinson House at 400 Northeast Fifth Avenue. Conceived in the 1920s by developer Glenn Curtiss and architect Bernhart Muller it is an example of Moorish Revival style of architecture. The original design was an extension of Islamic architecture featuring flat roofs, minarets, domes and parapets, comprising a symmetrical unity unequalled in South Florida. Wallace Robinson was manager of the Hammon Development Company that drained land, built roads and successfully farmed in Coconut Creek, Margate and Coral Springs. Present owners of the Robinson house are Keith and Bonnie White who have conscientiously maintained the house to ensure its authentic character.

The Pompano Beach Firehouse Museum at 215 Northeast Avenue was the original fire station that was constructed in 1926 and used until 1948. After using the building as a city storage facility, restoration began in 1986 and opened the following year as a museum. The original two firetrucks have been restored by a volunteer group of firemen and are on view at the museum, which is operated by the 5555 Society.

During the school year 2006–2007 there were nine public elementary schools with an enrollment of 5,925 and two middle schools with an enrollment of 2,552. There were two public high schools: Blanche Ely High (with 2,240 students) and Pompano Beach High (with an enrollment of 1,199 students). The Pompano Beach High School is Broward County's only fully comprehensive "A-rated" magnet high school emphasizing "International Affairs with Informational Technology." Magnet programs feature themed and intellectually challenging educational programs open to all. Magnet programs attract students by offering unique opportunities for in-depth experiences and study in specific areas. The total number of students attending the Pompano Beach public schools amounted to 12,121 in this academic year.

Northwest Pompano Beach produced a *2006 Community Resource Directory*, published under the direction of the Office of Housing and Urban Improvement and International Enterprise Development, that highlights the rebirth of this section of the city. The office of housing provides affordable living quarters, a need that must be filled locally and countywide, by connecting locally owned businesses to expanding opportunities. There is a business loan fund that provides capital to small businesses by partnering with banks. First time loans can range from as little as $500 to $25,000. As the pace of the economy moves forward, the seven-member Northwest CRA Advisory Committee helps to guide the Northwest Community Reinvestment Area concerning needed projects. The NWCRA has been approved by Broward County and the State of Florida; it is the largest in the state, occupying 3,048 acres from Dixie Highway and Powerline Road on its east and west boundaries, between Copans Road on the north and Atlantic Boulevard to the south. Northwest Pompano Beach also has established an extensive faith community

Pompano Beach

The high achieving Pompano Beach High School at 600 Northeast Thirteenth Avenue is noted for its International Affairs with Information Technology program. It is Broward County's only comprehensive "A-rated" magnet high school. *Broward County Public Schools.*

consisting of local congregations that offer worship services and support in childcare services, youth development programs, food services and sick and shut-in visitations. Local nonprofit service organizations also volunteer their time to assist.

A role model of success in the community is Richard McFadden. Richard's Barbershop services customers from West Palm Beach to Miami. McFadden relocated from Boca Raton to Pompano Beach more than four decades ago. From 1967 to 1980 he operated his business in Collier City, then moved to his present location at 210 North Flagler Avenue. Richard's Barbershop employs five barbers.

Starting in 1910 every decennial count has produced a consistent level of population growth—there has never been a decline in numbers, except for the last year listed, 2006. The United States Census has produced the following official decennial record:

1910	*269*
1920	*639*
1930	*2,614*
1940	*4,427*
1950	*5,682*

Contemporary Pompano Beach

1960	15,992
1970	39,012
1980	52,618
1990	72,411
2000	78,191

In addition to the census counts, the University of Florida has gathered data and has projected the following estimate of city population:

2001	85,932
2002	86,300
2003	86,334
2004	101,457
2005	101,712
2006	101,103

It must be noted that as a result of area annexations, the 2001 population included 7,741 Cresthaven residents. The 2004 population included 7,768 Leisureville, Loch Lomond and Kendall Green residents; and there were 6,505 Pompano Highlands residents. In 2005 the City of Pompano Beach was the sixth largest municipality in Broward County and the eighteenth largest municipality by population in the state of Florida.

A breakdown of the 85,932 people by Hispanic origin and race in 2001 is as follows: Hispanic origin: 9,030; not of Hispanic origin white: 52,768; not of Hispanic origin black: 20,407; and other: 3,727. It is clear that Pompano Beach is a multicultural society. The city covers 25.98 square miles with three and a half miles of beach in Broward County.

The city median household income in 2005 was $40,390; it was $36,073 in 2000. The 2005 median house/condominium was valued at $214,500; it was $135,700 in 2000. The median gross rent in 2005 was $878 and in the same year 14.4 percent of residents were living in poverty.

Pompano Beach is the birthplace of leading athletic personalities, some of whom are NFL players Al Harris (Green Bay Packers), Jerome McDougle (Philadelphia Eagles)

Pompano Beach

Kester Park at Northeast Fourth Street honors William L. Kester and his family for their contributions to the development of the city. *Author Collection.*

McNab Park at East Atlantic Boulevard honors the McNab brothers, who were among the leading pioneers of Old Pompano. The park features shuffleboard competition. *Author Collection.*

Contemporary Pompano Beach

The Aquamarine condominiums are among the most recent additions to the high-rise building trend on South Ocean Boulevard. They were completed in 2007. *Author Collection.*

and Zack Crockett (Oakland Raiders), NBA player Eddie Jones (Memphis Grizzlies and Miami Heat), college basketball player Johnny McCray (Bethune Cookman) and college football players Robson Noel (Jacksonville) and Weston Hill (Hampton).

A few select community leaders have been honored permanently with their names being designated at public facilities for giving many years of service to Pompano Beach. McNab Road and McNab Park both bear the name of W.H. McNab (of the pioneer McNab family) who served six years from 1924 to 1929 on what was then named the council. William L. Kester (of the Kester family) has a park named for him. His contributions were many in the growth of the city as councilman, promoter of tourism (linked to the Kester Cottages), banker, land developer, philanthropist and generally a booster of economic growth. His nephew, Stewart R. Kester Jr., also served as city commissioner and mayor. Emma Lou Olson has a civic center named for her. She gave many years of service as commissioner and mayor from 1976 to 1985, and 1990 to 1997. William J. Alsdorf, a commissioner and mayor, is honored with a park named for him at a boat-launching ramp on Northeast Fourteenth Street. The Herb Skolnick Community Center at Palm Aire is named for the commissioner/mayor who represented District 5 continuously from 1977 to 2003. Finally, the E. Pat Larkins Community Center at Northwest Sixth Avenue and Martin Luther King Jr. Boulevard is named for the civic leader from District 4. Larkins held the positions of commissioner or mayor from 1982 to 2000 and 2003 to the present. Of course, Founders Park at 316

Hurricane Wilma occurred in October 2005, producing devastating results throughout the city. Cars were tossed in the parking area of the Claridge condominiums next to the Criterion building, shown in background. *Author Collection.*

Contemporary Pompano Beach

Pompano Beach

Pompano Beach continues to reflect a multicultural society, as shown in this image of the Islamic Center of South Florida at Northeast Sixth Street. *Author Collection.*

Northeast Third Street pays homage to the early settlers who laid the foundation for a successful thriving city.

The pace of physical/environmental change has been accelerating as the city celebrated its one-hundredth anniversary. The time of the "Bean Capital of the World" of an agrarian society no longer applied. Developers and lobbyists seized opportunity after opportunity to buy, demolish and replace the old mom and pop motels along the beach with higher structures, condominiums or hotels, with increasing density. Such older condominiums as the Aegean, Atlantis, Christopher House, Claridge, Criterion, Renaissance I, II and III and Wittington, in a mile-long area south of Atlantic Boulevard on State Road A1A, have been renovated and upgraded. New ones are being added, such as the Aquamarine, City Place, Sonesta, Santa Barbara Hotel/Timeshare, The Plaza at Oceanside and Wyndam Royal Vista Time Share. What was once a primitive old country road with no sidewalks and drainage has become a heavily traveled urban thoroughfare with one north lane, one south lane and a center turning lane. Similar growth also has been taking place north of Atlantic Boulevard (the Luna), and south within the Lauderdale-By-The-Sea town limit with high-rise condominiums (Aquasul, Europa, Corniche and Cristell Cay) that have been added to the older structures.

The high-rise-eighteen-story WCI Plaza replaced the low-rise Oceanside Shopping Center. Opposite on the east side of A1A, the site on which the old Howard Johnson/Holiday Inn stood has since been demolished and a hotel will be built on the site. At

Contemporary Pompano Beach

The Hillsboro Inlet Marina, as seen in this 2007 image, has a long history as a center for boating and deep-sea fishing. The inlet leads directly to the Atlantic Ocean. *Author Collection.*

In 2007 the Isle of Capri, new owner of the Pompano Park Harness Track, inaugurated casino gambling. Other amenities were planned: hotels and shopping. This sign is at the Powerline Road entrance. *Author Collection.*

A sign with the city emblem welcomes visitors to Pompano Beach south of the Hillsboro Inlet Bridge on State Road A1A. The all-American award that the city received in 2005 can be seen at the top. *Author Collection.*

Contemporary Pompano Beach

The Ely Educational Museum, seen here in 2000, is located at Northwest Fifteenth Street and Northwest Sixth Avenue. It contains rare memorabilia honoring civic activist and educational leader Blanche Ely. *Author Collection.*

the south side of the intersection of Atlantic Boulevard and A1A larger buildings will eventually rise. Farther south, between the Claridge and Renaissance I condominiums, a proposed three ten-story hotel building project consisting of 586 units, on both sides of S.R. A1A, connected by two elevated pedestrian walkways, valet parking, two ballrooms and a 900-car robotic parking garage between the Claridge and Renaissance I condominiums is planned for the Ramada Ocean Beach Resort site that was destroyed by Hurricane Wilma in 2005. Debate has risen over the impact these projects will have on the beach and citywide environment, especially water, traffic, emergency evacuation and quality of life issues. Other barrier island issues involving flood insurance, beach renourishment and building codes will have to be resolved. Acclaimed state historian Gary R. Mormino, author of *Land of Sunshine, State of Dreams* (2005), offered this observation, "Florida is about taking chances. Governments could, of course, prohibit…construction along barrier islands and flood-prone areas, but powerful interests want the freedom to build along with federally [and state] subsidized insurance as a hedge against catastrophes."

Pompano Beach, as part of the Gold Coast, lies in the general path of hurricanes. The most intense and lowest level pressure hurricane ever recorded in an Atlantic storm registered at 882mb during Hurricane Wilma in October 2005. Wilma had a devastating effect on the city. (The year before there were four destructive hurricanes that hit Florida: Charley, Frances, Jeanne and Ivan.) Hurricane Wilma caused nearly

Contemporary Pompano Beach

An aerial view of the Hillsboro Inlet looks west beyond the Hillsboro Inlet Bridge and Intracoastal Waterway. The landmark lighthouse and Hillsboro Club can be seen at the lower right. *City Clerk*.

seventeen billion dollars worth of damage throughout the state. Despite all the upgraded codes implemented after Hurricane Andrew (1992), Wilma caused extensive damage. Throughout Pompano Beach traffic lights were downed, streets and canals flooded, boats tossed, trees snapped, automobiles flipped and landed on other vehicles, roofs blown away, power lines downed, retaining walls collapsed and telecommunications disrupted. Mini tornados ripped through condominiums such as the Renaissance I on the beach, crashing through windows in seventy-seven apartments and destroying at least ten apartments. The Ramada Ocean Beach Resort was damaged beyond repair. Air traffic was halted. Commerce stopped and schools closed.

As Pompano Beach continues to grow as a multicultural community, exemplified by the Islamic Center on Northeast Sixth Street, old and new residents have endured hurricanes throughout the years. But differences can be discerned. The hurricanes of 1926 and 1928 in Pompano were basically local events where the people fended for themselves. Today a hurricane reverberates throughout the social, economic and political spectrums of society. No longer can a state government, or even remote Washington, D.C., stand idly by. Aid is expected and is delivered by the billions, joining with the ongoing support of the Red Cross and other charitable organizations.

Natural disasters come and go. Situated along the Gulf Stream between Palm Beach and Miami, people continue to be attracted by Pompano Beach lifestyle. Its population has experienced a constant upward progression. Its magnificent municipal park system

is complemented by one of the finest beaches in the state. Community life is vibrant, its citizens active. Its government has been efficient and responsible, with a municipal tax rate among the lowest in South Florida. The physical frontier has been conquered in American history, but newer challenges in a postindustrial society will emerge in the future, especially involving the environment. But the tiny primitive community of 1908 that comprised a few hardy pioneers at Lake Santa Barbara and the railroad station at Flagler Avenue has grown into a mature cohesive community of more than 101,000 people. The Pompano Beach centennial stands firmly on a foundation of one hundred years of remarkable historical achievement.

Bibliography

American Guide Series. *Florida: A Guide to the Southernmost State.* New York: Oxford University Press, 1939.

Broward Legacy. Various editions.

Broward County Historical Commission. *Celebrating Broward County's 90th Birthday.* Fort Lauderdale: 33rd Annual Pioneer Days Souvenir Program, October 2005.

Butler, David F. *Early History of Pompano Beach.* N.p., n.d.

_____. *Hillsboro Lighthouse.* Pompano Beach Historical Society, 1997.

Cavaioli, Frank J. *Pompano Beach.* Charleston, SC: Arcadia Publishing, 2001.

_____. *Pompano Park Harness Track.* Charleston, SC: Arcadia Publishing, 2005.

_____. *Lauderdale-By-The-Sea.* Charleston, SC: Arcadia Publishing, 2003.

Department of Planning. *City of Pompano Beach Statistical Information Package.* Pompano Beach, 2006.

Douglas, Marjorie Stoneman. *The Everglades: River of Grass.* Marietta, GA: Mockingbird Books, 1947.

Douglas, Marjorie Stoneman, with John Rothchild. *Voice of the River: An Autobiography.* Sarasota, FL: Pineapple Press, 1987.

First Baptist Church of Pompano Beach. *The Harvest Plentiful, May, 2005: 90th Anniversary.* Pompano Beach, 2005.

Bibliography

Florida Trend. Various editions.

Fowlkes, Clint, ed. *Rotary Club of Pompano Beach, Florida, 1930-1980.* Pompano Beach, 1980.

Garner, Edward L. (Bud). *Tales of Old Pompano.* Pompano Beach Historical Society, 1998.

Genealogical Society of Broward County. *Pioneer Cemeteries of Broward County, Fla. 1997.*

Harvey, Eunice Cason, ed. *Making History Together at Mount Calvary Baptist Church, 1906–1983.* Pompano Beach, 1983.

Kemper, Marilyn. *Pompano In Perspective: A Comprehensive Documented History of the City of Pompano Beach.* Pompano Beach, 1984.

Kester, Stewart R. *Pompano Beach Diamond Jubilee Commemorative Book Celebrating 75 Years, 1908–1983.* Pompano Beach, 1983.

Landini, Ruth H. *A 50-Year History of the First Presbyterian Church of Pompano Beach, 1954–2004.* Pompano Beach, 2004.

McGovern, Bernie, ed. *Florida Almanac 2007–2008.* Gretna: Pelican Publishing, 2007.

Miner, Frances H., with an Introduction by Stuart McIver. *History of Broward County.* Reprint of the WPA Federal Writers Project of 1936.

Mormino, Gary R. *Land of Sunshine, State of Dreams.* Gainesville, FL: University Press of Florida, 2005.

Pompano Beach Elks. *Dedication 1984.* Pompano Beach: B.P.O. Elks Lodge 1898, 1984.

Pompano Beach Historical Society. *Pompano Historical Home Tour.* 2001 and 2007.

Pratt, Theodore. *The Barefoot Mailman.* New York: Duell, Sloan and Pearce, 1943.

Robson, Lorena H. *History of Pompano Beach.* Pompano Beach Historical Society, 1974.

St. Martin-In-The-Fields Episcopal Church. *25th Anniversary, 1950–1975.* Pompano Beach, 1975.

Temple Sholom. *60th Anniversary, Diamond Jubilee.* Pompano Beach: Temple Sholom, 2005.

Bibliography

United States Census Bureau. *Profile of General Demographic Characteristics: 2000; Geographic Area: Florida.*

WPA Writers Project. *The Intracoastal Waterway: Norfolk to Key West.* Washington, DC: Government Printing Office, 1937.

Wallace, Margaret, ed. *The Story of Pompano Beach.* Miami, FL: Jo Williams Publications, 1957.

Index

A

Ali, Florence Major 31
Anderson, Francine G. 77, 78
Armbrister, Hazel 32
Ashley Gang 49, 52
Ashley, John 49, 52

B

Barefoot Mailman 18–20
Berghell, Alfred A. 20
Blount, William H. 30
Broward, Napoleon 41, 42
Butler, David F. 54

C

Coleman, James Emanuel 35

D

Davis, T. C. 38, 40
Douglas, Marjorie Stoneman 42

E

Ely, Blanche 13, 32, 35, 77, 139

F

First Baptist Church 44, 45
First Presbyterian Church 105
Flagler, Henry Morison 18
Florida East Coast Railroad 11, 18, 29, 36, 60, 65, 75, 79

G

Garner, Edward L. (Bud) 63
Golden Jubilee 11, 20, 31, 106
Goodyear blimp 71–73
Great Depression 55

H

Hamilton, George 132, 133
Hamilton, James 18
Hammon, Hiram F. 30
Harvey, Eunice Cason 35
Hillsboro Club 21, 22
Hillsboro Lighthouse 19, 20, 21, 22, 23, 54, 74, 106, 153

I

Indian Mound 15, 16

J

Jackson, Andrew 17
Jones, Ora L. 31, 79, 80

K

Kester, William Livingston 59–63

L

Lake Santa Barbara 11, 15, 25, 26, 27, 29, 40, 41, 42, 89, 125, 152
Larkins, Pat 32, 40, 81, 134, 143
Lauderdale-By-The-Sea 20, 105, 108, 133, 146, 153

Index

Lutheran Church 101
Lyons, Henry Bud 65

M

Malcolm, Herbert L. 21, 22
McClellan, George Sterling 31
McNab, Harry 13, 27, 79, 132, 137
McNab, Robert 13, 132, 137
Methodist Church 44
Miner, Frances H. 55, 57
Mizell, John R. 47
Model Land Company 18

N

Nineteenth Amendment 46

O

Oceanside Shopping Center 115, 117, 146
Olson, Emma 72
Our Lady of the Assumption 100

P

Palm Aire 112, 143
Plant, Henry Bradley 18
Pompano Fashion Square 112, 125, 133
Pompano Harness Track 29, 48

R

Reconstruction Period 17
Rolle, Esther 36–38
Rolle, Jonathan 36

S

Sample-McDougald House 134, 135, 138
Saxon, John Andrew 29
Smoak, L. R. 27
St. Coleman's 100
St. Gabriel's 104
St. Martin-In-The-Fields 99
State Farmers Market 30, 38, 64
Stillman, Hugh D. 81
Swain, Jack 32
Swamp Lands Act 17

T

Temple Sholom 98
Tequesta American Indians 15
Thurston, Alfred Ernest 78
Turner, Aden Waterman 42

V

van Lennep, Frederick L. 123

W

Walton Hotel 52, 53
Warren, Elizabeth J. 25
Westview Cemetery 38
Women's Club 36, 95
WPA Federal Writers Project 16, 154

About the Author

Frank J. Cavaioli, professor emeritus at Farmingdale State University and visiting professor at Florida Atlantic University, holds the BA, MA and PhD degrees. Author of ten books, more than fifty scholarly articles and a contributor to various encyclopedias, he is a longtime proponent and researcher of state and local history. Among the many awards he has received, he is particularly proud of the following: Freedoms Foundation George Washington Honor Medal, Colonial Dames Society Award, Immigration History Research grant at the University of Minnesota, Moody Research grant at the Lyndon Baines Johnson Library, and SUNY Chancellor's Award for Excellence in Teaching at Farmingdale State. He is a Newberry Library Research Fellow and a National Endowment for the Humanities Fellow at the University of Michigan.

Visit us at
www.historypress.net